HOW TO PAINT
WATERCOLOURS

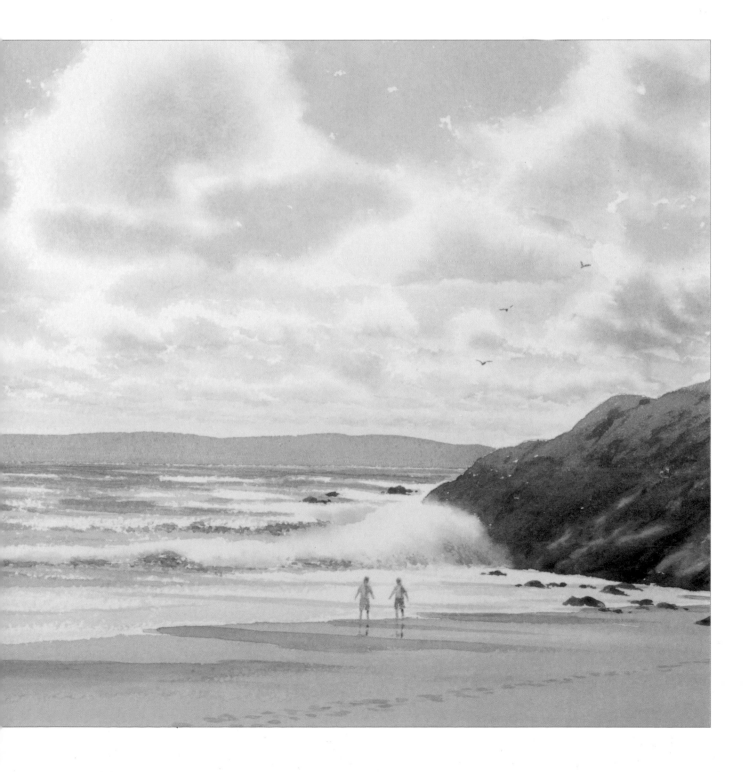

Dedication

*To all those who taught me and
made me the artist I am.*

HOW TO PAINT
WATERCOLOURS

JEREMY FORD

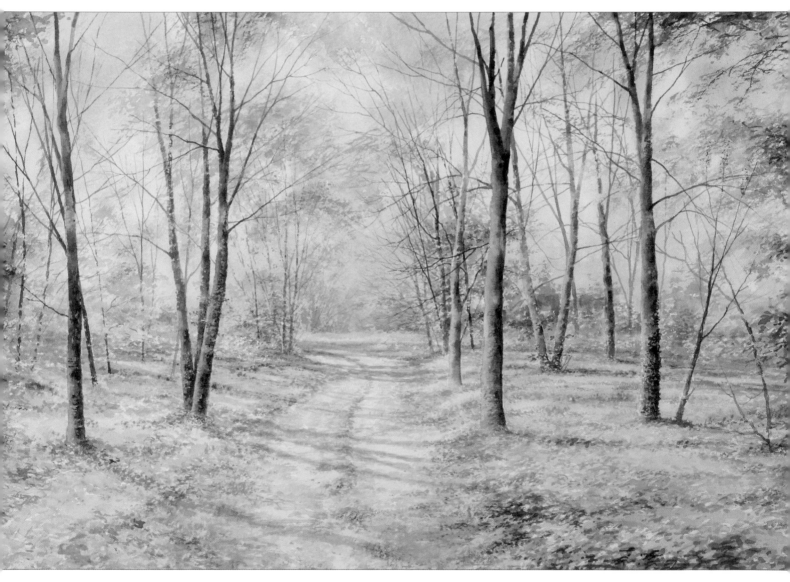

SEARCH PRESS

This edition published in 2019

Search Press Limited
Wellwood, North Farm Road,
Tunbridge Wells, Kent TN2 3DR

Previously published as *How to Paint: Water Colours* in 2008, 2009 (twice), 2010, 2011, 2012, 2015, 2017

Text copyright © Jeremy Ford 2008

Photographs by Debbie Patterson at Search Press studios

Photographs and design copyright © Search Press Ltd. 2008

ISBN: 978-1-78221-745-9

The Publishers and author can accept no responsibility for any consequences arising from the information, advice or instructions given in this publication.

Suppliers
If you have difficulty in obtaining any of the materials and equipment mentioned in the book, please visit www.winsornewton.com

Publishers' note

All the step-by-step photographs in this book feature the author, Jeremy Ford, demonstrating watercolour painting. No models have been used.

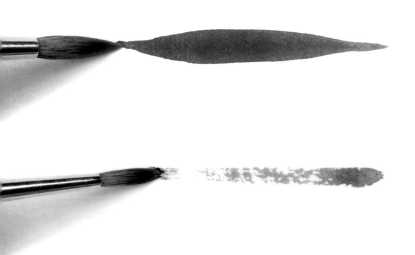

Acknowledgements

Thanks to my editor, Edd, for his great patience throughout the production of this book, and to the Society for All Artists from whom I have greatly benefitted.

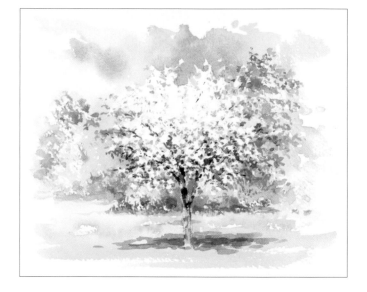

Cover
Old Ways, Swaledale
45¾ x 35½cm (18 x 14in)
This was worked from a photograph taken on a breezy walk in early spring.

Page 1
Detail from Blustery Day at Hope Cove
50¾ x 40¾cm (20 x 16in)
This detail is taken from the first project on pages 30–39.

Page 3
Bluebells at Bretton
50¾ x 40¾cm (20 x 16in)
I had to be patient for the sun to come out, but it was well worth the wait!

Opposite
Geraniums
40¾ x 50¾cm (16 x 20in)
These wonderful flowers were in just the right place together in my garden.

Contents

Introduction

When I was asked to write this book, one of the first thoughts I had was 'what can I say that has not already been said by someone else?' As I thought further I came to the conclusion that nobody has written a book about the way that Jeremy Ford paints watercolour, so here it is!

We all take information from various sources, keeping what we find helpful and discarding what we do not. This book is full of the techniques of watercolour painting that I find helpful as an artist. They have been developed and refined over many years of watching, reading and listening to others, as well as countless hours of experimentation, trial and error.

Within these pages there is a wealth of information for the beginner and my hope is that it will form the basis of your repertoire in becoming a water-colourist. There are also exercises and techniques here that, as far as I know, no one else has covered before, so there is also plenty to stimulate the more experienced painter.

We will cover a comprehensive range of watercolour techniques as well as examining various materials; selecting paper, paints, brushes and other painting equipment. We will cover colour mixing, the importance of light, tone and contrast, and how to apply all this to painting a wide range of subjects. I will also show you how to avoid many of the problems associated with watercolour painting.

I am often asked if I think that anyone can learn to draw and paint and my response is unequivocally 'yes!' However, some people seem to have a natural aptitude towards art, as some people learn to catch or drive more quickly and easily than others. The rate at which learning takes place will depend upon the extent to which you are prepared to practise and how keen you are. You must not be put off when things become hard or difficult because a perceived failure can be a stepping-stone to eventual success. Watercolour painting needs time for study, so try to be prepared to do some as often as you conveniently can.
Happy painting!

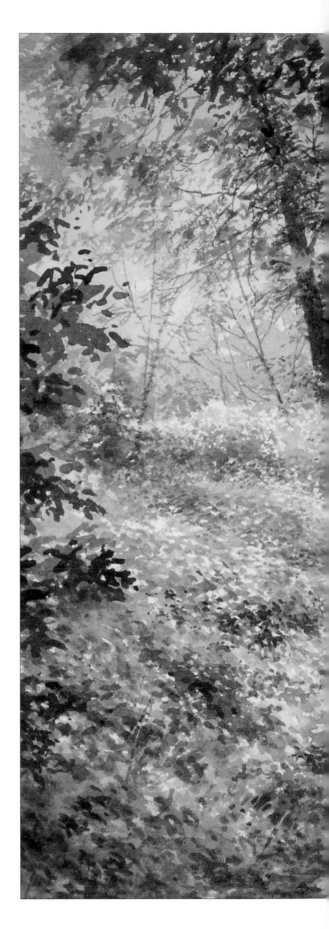

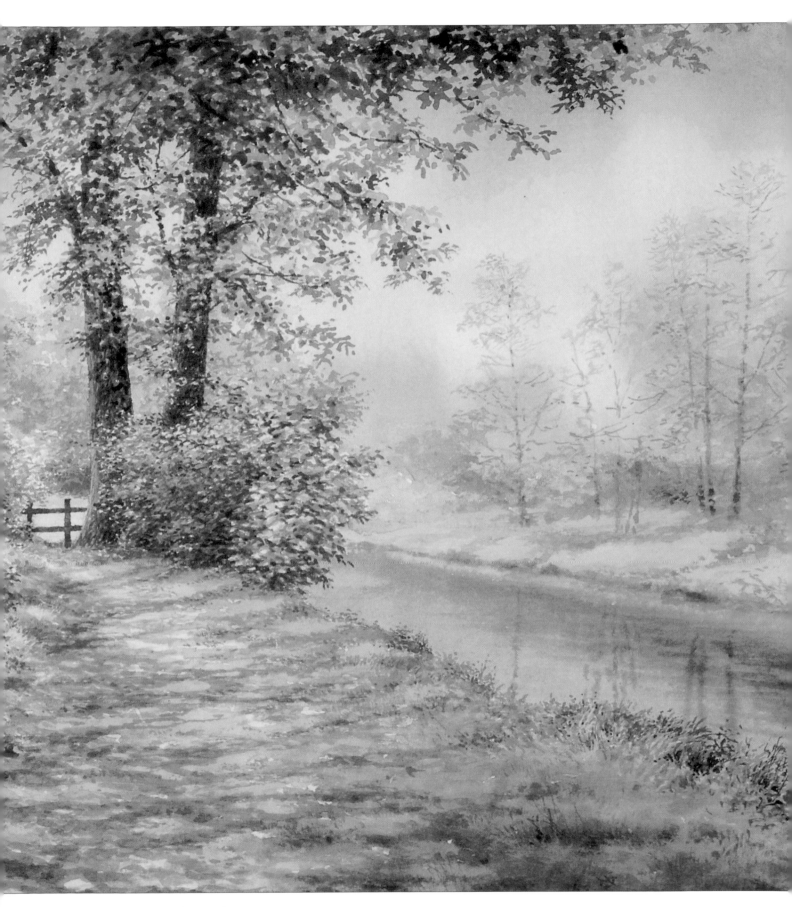

The River Barle at Withypool
38 x 30cm (15 x 11¾in)
This was worked from a photograph taken on holiday in Exmoor.

Materials

Choosing art materials is very much a personal decision and what one person finds useful another might not. Most people start off with a small amount and add to it, but it is surprising how little an artist needs to get started on the road to creating pleasing watercolour pictures.

Watercolour paints

Watercolour paint comes in tubes of soft paint or as pans of hardened paint. Boxed sets of pans can be bought in a variety of sizes depending on how many colours you require. These will contain half-pans or full-pans. These boxes can also be bought empty from good art suppliers and the pans bought individually. This allows you to choose your own colours, and avoid buying a box of paints that has lots of colours in it that you do not need or want.

Tubes of paint can also be bought in a boxed set, but are more popularly sold individually. They come in a variety of sizes and provide a lot of paint more easily. I recommend tubes for larger works.

Watercolour paint also comes in two categories: artists' quality and students' quality (also known as second range). Students' quality colours are usually much cheaper than artists' quality, but much more students' quality paint is required to get strong mixes, so you tend to use it up a lot faster than artists' quality. Some student range pans can be very hard and require a lot of working with a wet brush to get a quantity of strong colour. The same can happen with tubes of student range paint which has gone hard in the palette. Constant working in this way can damage your brushes over time, causing them to lose their point more quickly than usual.

For these reasons, I always use artists' quality paints. I use pans for outdoor use because they are easily portable, and tubes for studio use when I am more likely to need larger quantities of colour for larger pictures. I select my own colours in tubes and pans and use the same specific colours in both forms which will give me every mix I need.

A variety of watercolour paints in tubes and pans.

Basic palette

On this page are the six colours I consider most important, and they make up a great basic palette. It is possible to make virtually any other colour from these six paints (with practice!).

Cadmium yellow This is a warm, opaque yellow.

Winsor lemon This is a cool, transparent yellow.

Permanent rose This is a cool, transparent red.

Cadmium red This is a warm, opaque red.

Winsor blue (green shade) Also known as phthalocyanine blue, or phthalo blue for short. This is a cool, transparent blue.

French ultramarine This warm, transparent blue is often known simply as ultramarine.

Opacity and transparency

The opacity or transparency of a colour can be tested by painting a line of any dark colour on a piece of paper. After this has dried, paint the colour to be tested over the line with a strong mix of that colour. An opaque colour will obscure the line almost completely, whereas a transparent colour will allow the dark line to be seen underneath.

This information is contained within a colour chart available from your local art shop or directly from Winsor & Newton.

Laying out your palette

Keep related colours next to each other, as shown below. For larger quantities of paint and mixes, larger or additional palettes may be needed.

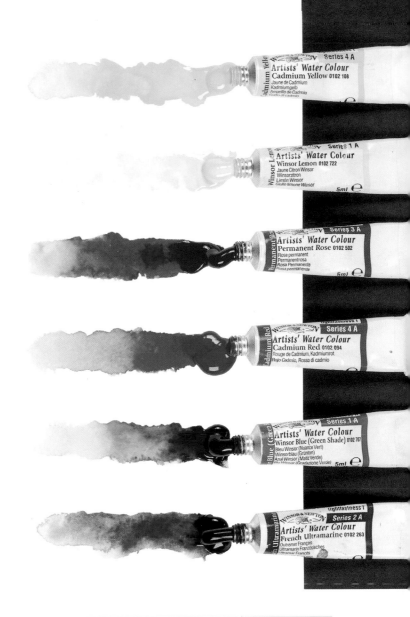

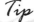

Tip
If a plastic palette remains stained after cleaning, a tiny amount of oil on a tissue will remove any stains. Be sure to wash the palette in soapy water afterwards.

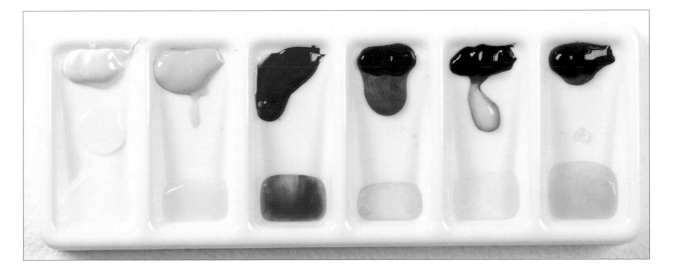

Expanding your palette

I find these extra colours useful as they crop up regularly, especially in landscapes. There may be occasions when you want a large amount of an earthy colour (for sand on a beach painting, for example), and it is much more convenient to use yellow ochre or raw sienna as a base than to mix it from your basic palette.

Winsor green (blue shade) This is a very vivid green and would not normally be used on its own, but it can give exquisite transparent colour mixes, producing good, natural light- to mid-greens when mixed with yellow ochre or raw sienna. When Burnt Sienna is added to these mixes dark, transparent greens will result.

Burnt sienna This is a beautiful autumnal orange-brown. It also makes great shadow and dark brown mixes when added to French ultramarine.

Raw sienna This colour is useful for sand and stone in landscapes.

Yellow ochre Like raw sienna, this is fantastic for earthy tones.

Cerulean blue Cerulean blue is a cool blue, leaning towards the green side of the spectrum. This colour is opaque and has a tendency to granulate and separate which can in certain circumstances be useful. However, very dilute Winsor blue (green shade) gives a mix which is visually very similar.

Mixing your own colours

The following colours are all very useful, and can be bought ready-mixed, or made yourself. In combination, the six basic paints (see page 9) and the colours above can be used to mix all the other colours you will need for the demonstrations in this book. Try mixing various colours before you start, perhaps trying them out in a sketchbook.

 Cobalt blue is a beautiful colour and can be created from a mix of French ultramarine and Winsor blue (green shade). This will give a transparent cobalt blue. Alternatively, French ultramarine can be mixed with cerulean blue, giving a semi-opaque cobalt blue.

 Sepia, **Payne's gray** and **indigo** can all be mixed from varying quantities of French ultramarine and burnt sienna.

 Black can be mixed from varying quantities of mostly Winsor blue (green shade) with permanent rose and Winsor lemon. It is also possible to replicate black by mixing cadmium red and Winsor blue (green shade).

 All of the greens used in this book can be mixed with the yellows and blues mentioned, sometimes with a tiny touch of either red if they need dulling or neutralising.

> *Tip*
> Yellow ochre, raw sienna and burnt sienna can be mixed from varying quantities of Winsor lemon, permanent rose and French ultramarine.

Brushes

Watercolour brushes can be made using natural animal hair (such as sable, squirrel or goat), a synthetic substitute, or with a combination of natural and synthetic fibres. Natural brushes hold more water and usually retain their shape longer than their synthetic counterparts. Synthetic brushes are cheaper but generally do not last as long.

Whether you buy natural or synthetic brushes, or a mixture of both, will depend upon the techniques you wish to achieve as well as your budget. I often use synthetic brushes for shoving and dragging paint over a rough paper surface to get a certain effect because the effect can not be achieved as easily with a soft, natural brush.

However, if I want to add a glaze (a transparent layer of watery paint over something already painted) to a piece, I prefer to use a natural brush because it holds more watery paint and is softer, which reduces the likelihood of disturbing the dry paint underneath.

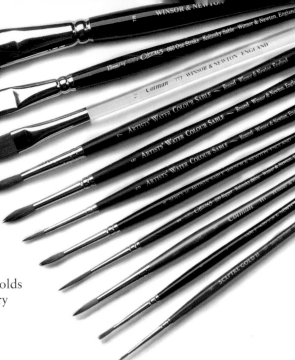

Shapes

I use various brushes for different purposes to achieve a variety of effects.

Round brushes are the most widely used in watercolour painting and come in a range of sizes to suit the size you are painting. Thicker at the base of the ferrule (the metal collar), round brushes come to a fine point at the tip.

Flat brushes vary in width depending on the size, but all are thin from the ferrule to the tip. I use a fine synthetic ½in flat which is particularly good for lifting out colour on a picture. I also use a sable flat brush but this is better for washes and will not lift out well because it is so much softer and does not have as much resistance.

Mop brushes can useful for covering paper with water before applying paint and can be used for painting on a large scale. These are very soft and will hold a large amount of water for this purpose. Any soft large brush can be used for laying down washes of water or watery colour.

Filberts are brushes shaped a bit like a cross between a flat and a round brush; it is flat in shape but round at the edges.

Rigger brushes are pointed and have a very long tip. The tip usually comes to a point, but riggers can also have flat or square tips. They are good for painting fine lines, making them ideal for painting thin branches on trees, grasses, poles, posts and boat masts. Originally they were used on paintings for the rigging of old ships as the brush holds a lot of paint and is therefore ideal for painting a continuous line.

Fan brushes create a fan shape and can be useful when painting massed twigs on a winter tree, grasses and other foliage.

Sizes

Brush size selection will depend upon the size you are working and what you feel comfortable with. I rarely use a round brush larger than a size 16, and more usually tend towards a number 12 or 10 to start with, then go on to smaller brushes if more detail is required.

Tip

A good starting range of brushes should include a large flat brush; rounds in the following sizes: 16, 10, 8, 6, 3 and 1; a size 2 or 1 rigger, and a ½in synthetic flat brush.

Brushstrokes

Some brushes are more practical for certain effects than others: flat brushes give angular strokes, so they are better for rocks than rounds. Equally, I never use flats for clouds or foliage.

The amount of paint you pick up is important. Large areas require a lot of paint, while a smaller amount is more appropriate where more control is needed. As always, practice will help you discover which brush and how much paint to use!

Increasing the pressure while drawing a round brush across paper can change a fine line into a broad one.

Flat brushes give a broad or narrow stroke depending on their angle. They are also useful for lifting out (see page 15) or removing paint where previously applied.

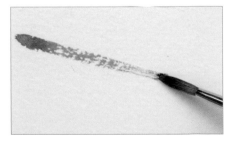

Using a light stroke with a dry brush (i.e. a brush with little paint on it) gives a broken effect on textured watercolour paper.

Papers

There are lots of different watercolour papers around, and I suggest that you try as many as you can. That way, you will quickly find the ones that suit you for the kind of work you want to do.

Finish

There are three different surfaces for watercolour paper: Rough, Cold Pressed or 'Not', and Hot Pressed. Hot-pressed paper is very smooth and ideal for very detailed work. I particularly like rough-surfaced papers which allow many more painting techniques. 'Not' surface papers are neither rough nor smooth but in between.

Weight

Watercolour papers are weighed in grams per square metre (gsm) or lbs. This can be a little confusing because the gsm and lbs weights do not correspond to each other.

The easiest way to refer to paper weight is using the gsm method, as it is measuring the grams per square metre, rather than the more technical lbs weight. I use mostly 300gsm (140lb) and occasionally 425gsm (200lb) or 640gsm (300lb) weight paper.

Note that the more lightweight papers may distort or buckle when wet.

Granulation

Some paints have a tendency to granulate. This is where the pigment separates into tiny clusters and does not show a smooth, even finish. It happens with some colours more than others, some makes more than others, and on some papers more than others.

There is a paint additive called granulation medium which helps this to happen. It can be particularly useful for creating texture in a painting.

Some makes of French ultramarine tend towards granulation, as does cerulean blue. It can be more obvious with the addition of certain other colours, particularly on textured papers.

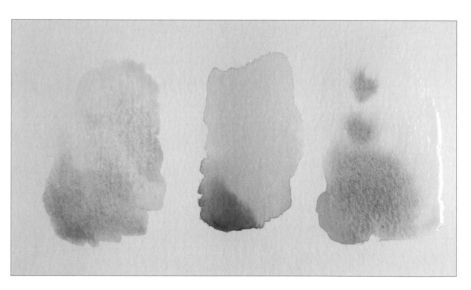

You can see here that the cerulean blue on the left granulates, while the visually similar Winsor blue (green shade) in the centre does not.

The mix on the right is cerulean blue and cadmium red, both granulating colours. The two colours do not stay properly mixed, but begin to separate. This causes the red to emerge at the edges of the mix, where the paper is wet.

Other materials

Although I use all of these other materials, what you choose is very much a matter of what suits you.

Kitchen roll This is useful for wiping excess paint or water from the brush and for cleaning my palette. I find it essential!

Masking fluid A very useful aid to painting, this is liquid rubber solution that protects the paper surface so you can paint over it, then remove it later, revealing clean paper. Do not use a good brush to apply it. Use a plastic or synthetic brush and dampen the brush before use. If the masking fluid is too thick, add a drop or two of water to thin it and make it flow better.

Easel, desk or drawing board At home I use an angled desk; outside I use an easel and in classes I use a board; but you should use whatever feels most comfortable. Take your pick!

Palette I use a variety of plastic, ceramic or metal palettes depending upon what I am doing.

Water dropper It makes painting so much easier if you can transfer water from your container to your palette with a dropper or pipette. You can also use it to move watery paint from one part of the palette to another.

Hair dryer You can save a lot of time by using a hair dryer. They are especially useful for speeding up the drying process when indoors.

Masking tape If using thick paper, I use it to secure the paper on a board. If working on a loose-leaf pad, it is handy for sticking the corners down so they do not curl up when the paper is wet.

Pencils and eraser An HB, B or 2B pencil is ideal for drawing and is easily removable (as long as you do not press too hard) with a putty eraser. Avoid very hard erasers as they can damage the surface of your watercolour paper.

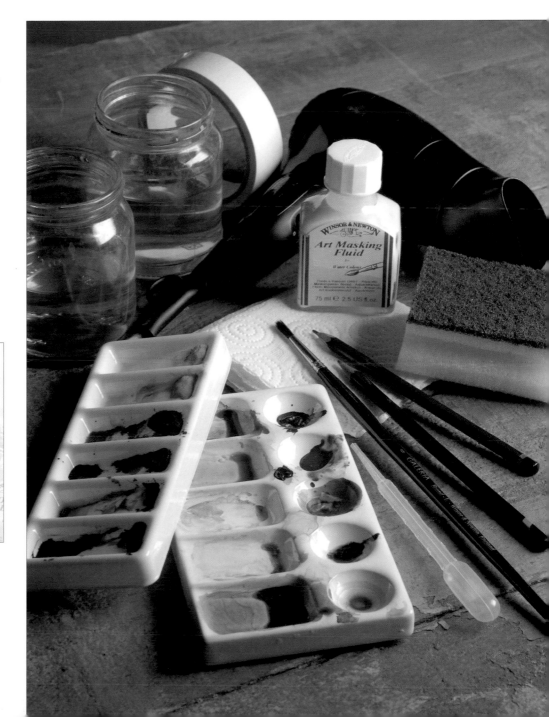

Tip

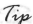

When applying masking fluid, keep washing your brush in water between applications, then remove the excess water on to some kitchen roll before dipping into the masking fluid again. This prevents layers drying on the brush and turning it into a rubber stick!

Basic techniques

This section provides an introduction to the basics of using brushes with watercolours. Remember, practice makes perfect!

Wet-into-wet

This technique is useful for misty backgrounds and incidental flowers and foliage. When painting wet paint on wet paper, it is important to get the consistency right. Try adding greater or lesser amounts of water and practising on some spare paper to find the different effects you can achieve.

If your paint or your paper is too wet, the paint runs uncontrollably. If the paper is not too wet (so that if you held it up, water would not drip off it) and the paint is not too watery you can give an effect of softness and distance.

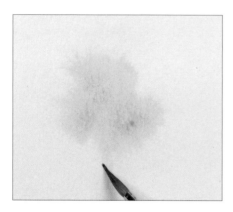

1 Wet the paper with a large brush, then drop in a thin wash of your first colour in a simple tree shape.

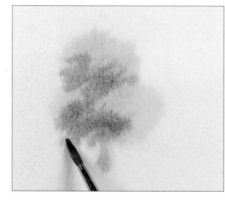

2 While the paint is still wet, add your second, darker colour to add shading. Note how the paints bleed together, creating a soft effect to the finished tree.

Tip

Try to avoid going back into a wash once it has started to dry, because if the paint you are adding is wetter than the existing wash, the watery paint on your brush hits the damp or drying paint on the paper and moves it, leaving a tide mark sometimes called a 'cauliflower' or a 'runback'.

Wet-into-dry

A lot of painting is done wet-into-dry as the hard edges of the brushstrokes bring it into focus. Many useful techniques can be achieved working with varying degrees of wetness.

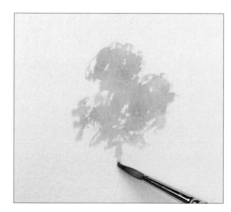

1 Paint your first colour shape on to dry paper. Note how you can create a broken effect impossible with the wet-into-wet technique.

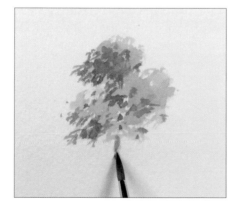

2 Allow the paint to dry before adding the second colour to shade. Notice how the colours do not bleed, allowing you to create hard edges and dappled effects.

Lifting out

This technique can be used to bring some light back into something that has already been painted by removing some wet, damp or dry paint. It is useful for highlights, particularly on foliage such as the veins or spines of close-up leaves, the shine on glossy leaves and grass, or flower stems against a dark background.

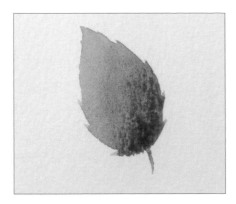

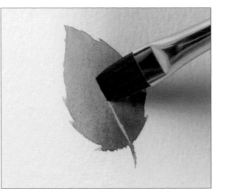

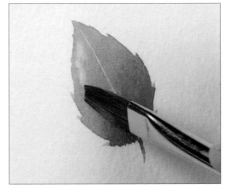

1 Paint a simple two-tone leaf and allow to dry.

2 Dip a ½in series 777 flat brush in water, remove the excess with a tissue, and run the edge along the area to be lifted out: in this case, the vein.

3 Use the corner of the brush to lift out a soft highlight at the top left of the leaf.

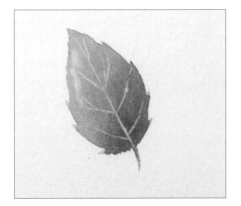

4 Lift out smaller veins radiating from the main vein to finish.

Damp-into-damp

This technique is similar to wet-into-wet but not quite as much water is used. It it useful for out of focus effects. The paint needs to be more viscous so it does not run as much. Again, avoid going back in with paint that is too wet.

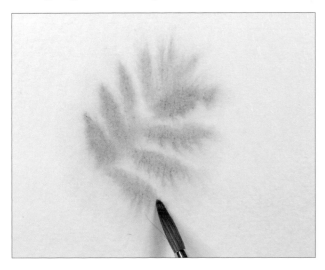

1 Wet your paper and allow it a little time to dry until it is merely damp. Using a fairly viscous mix of paint gives a similar effect to wet-into-wet, but you have more control over where the paint bleeds, allowing more precise application, as shown by this fern.

Dry brush

This technique is useful for a variety of textures such as wood, stone, shingle, foam, or in fact anything that needs to look rough. It might take a bit of practice to get the consistency right because the paint needs to be thicker or drier than you would normally use.

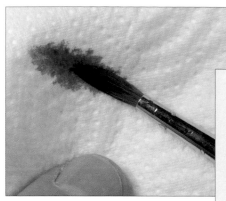

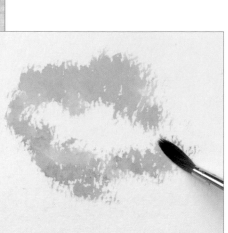

1 Load your brush with a fairly dry mix of paint and draw it across some tissue to remove most of it.

2 Use the edge of the brush bristles with a gentle scrubbing motion to create an uneven, scruffy effect. This is useful for clouds.

Splitting the brush

Particularly useful for winter trees, grasses and textures, this technique can be done with any round brush, although some split more easily than others. Again, getting the correct consistency of paint is important, so do not make the paint too watery. Try not to be too heavy-handed and use the brush gently.

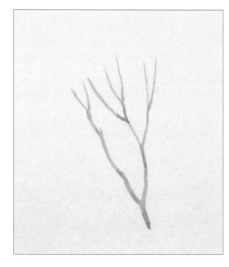

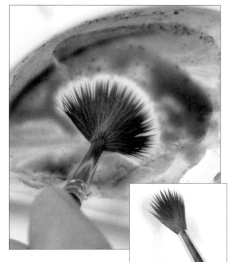

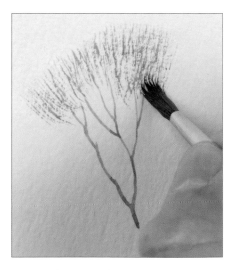

1 Paint some tree branches wet-into-dry with the point of a size 4 artist's watercolour sable.

2 Press the brush into the paint on your palette until it fans out as shown in the inset when lifted.

3 Use short strokes to create twigs and foliage on the ends of the branches.

Sponging out

If a painting gets blotchy or uneven, sponging out can restore work by removing patches of uneven paint, unwanted hard edges, or 'cauliflowers' etc. Soak a big household sponge (do not squeeze it out) and wash it over the affected area (over a sink!) and watch it soften. Different papers respond differently, so you may need to repeat the process in some circumstances.

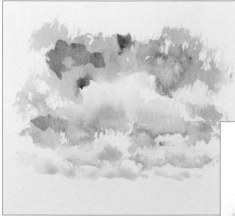

1 Identify the problem area. In this example, the sky has many backruns, hard edges and is patchy. Make sure the area is completely dry.

2 Hold the painting over a sink, then soak a household sponge and run it gently over the whole area, without squeezing it. Do not scrub the painting too much.

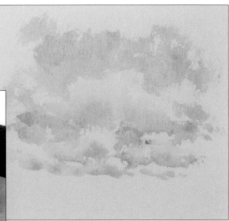

3 Squeeze out the sponge and repeat until the area is softened. If you like, you can add more colour while the paper is wet.

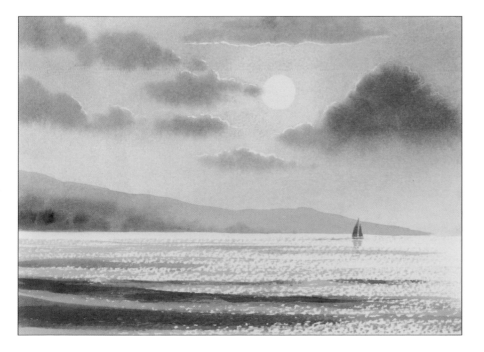

In this simple tonal study, various techniques were used for different effects.

Masking fluid was used on the moon and when dry, the paper was wetted with clean water down to the horizon. A pale wash of colour was applied from the top down to the horizon, and the clouds were then dropped in wet-into-wet. The light edges of the clouds can be done by lifting out or with white watercolour or gouache paint once the clouds are dry.

The hills were painted wet-into-dry and the hazy trees at the bottom of the hills were added wet-into-wet or damp-into-damp. The sparkle on the water was painted damp-into-dry, so the lack of water on the brush creates a hit and miss effect as the brush is dragged across the paper. The darker waves were added once the rest of the water area had dried.

Colour

This section concentrates on some simple colour theory that explains how watercolour paints behave, and how we can use colour to produce beautiful paintings. A little knowledge goes a long way!

The colour wheel

The colour wheel shown here will help to explain how we can mix bright, vibrant colours using a small range of paints.

No three primary colours of paint will give us the full range of mixes we wish to achieve, because watercolour paints are not a pure hue (see opposite), but rather are slightly biased towards other colours. French ultramarine is a blue that is biased towards red, for example, and so appears slightly violet.

Every artist has their own favourite colours. I use colours which are nearest to the bias of the three primary colours: six colours (two reds, two blues and two yellows). This is shown in the colour wheel below.

In the outer ring, you can see how the secondary colours are made up of combinations of the six primary-coloured paints I use.

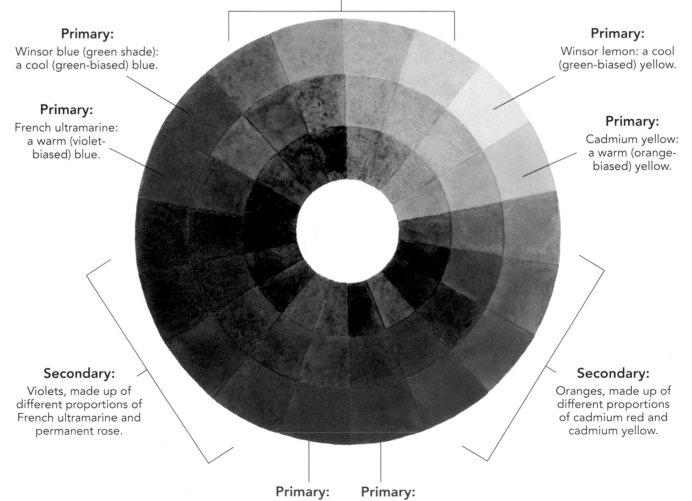

Secondary:
Greens, made up of different proportions of Winsor blue (green shade) and Winsor lemon.

Primary:
Winsor blue (green shade): a cool (green-biased) blue.

Primary:
French ultramarine: a warm (violet-biased) blue.

Primary:
Winsor lemon: a cool (green-biased) yellow.

Primary:
Cadmium yellow: a warm (orange-biased) yellow.

Secondary:
Violets, made up of different proportions of French ultramarine and permanent rose.

Secondary:
Oranges, made up of different proportions of cadmium red and cadmium yellow.

Primary:
Permanent rose: a cool (violet-biased) red.

Primary:
Cadmium red: a warm (orange-biased) red.

Primary and secondary colours

Primary colours are those colours which cannot be mixed from any other colour: red, blue and yellow. Secondary colours are combinations of the primary colours: orange, violet and green.

Different secondary mixes can be achieved by combining different primaries. For example, mixing cadmium red with Winsor blue will make a different purple to that made by French ultramarine and permanent rose. Experiment with your paints to find the mixes you like.

Warm and cool colours

Paints are sometimes described as warm or cool. Broadly speaking, colours which are biased towards the red end of the spectrum are warmer while cooler colours tend towards the violet end of the spectrum.

The temperature of a colour can help you with certain effects in painting, because cool colours appear to recede into the distance, while warm colours advance towards the eye. Using cool blues for mountains helps to give a sense of distance, for example.

Hue and tone

As I mentioned earlier, **hue** is the property of a paint that gives it a specific colour. Cadmium red and Permanent rose are red hues, for example. **Tone** is the relative lightness or darkness of a colour.

Hue can be altered by adding one or more different paints to the original colour. This allows us to mix an almost infinite range of colour using a relatively small number of paints.

Tone can be easily altered by adding more or less water: the more dilute the mix, the lighter the tone.

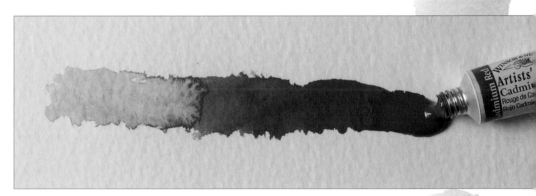

The hue of this cadmium red is not altered by the addition of water; but the tone becomes lighter.

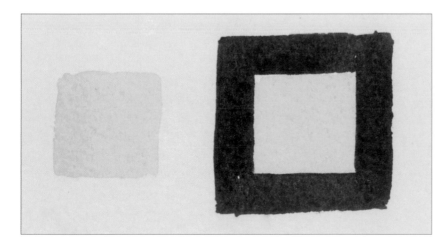

Local colour

The context of a colour dictates its appearance. In the diagram to the left, the yellow in the dark box appears to be lighter than the yellow on its own even though they are the same colour, owing to an optical effect.

We can use contrasts such as this to make something particularly striking or bright.

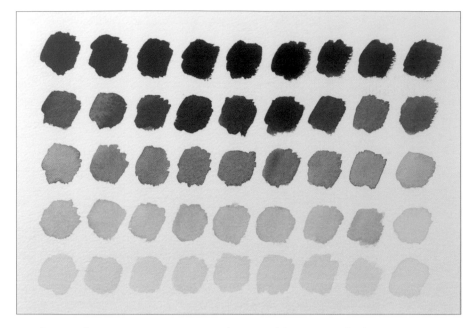

Colour grids

Painting colour grids such as these help you to learn a lot about colour mixing and tonal variation. The hue changes as the blue is added to the red in tiny quantities and the red is added to the blue until they meet in the middle.

As each hue is mixed, a weaker tone is painted underneath each one with the addition of a little water. Here we can see a large range of mixable colours from two of our six basic colours.

A colour grid using permanent rose and Winsor blue (green shade).

Greens

Mixing greens frequently causes problems for beginners, but if you paint a colour grid with a combination of one of our two yellows and one of our two blues, you will see some of the greens we can mix.

You can paint more colour grids with each combination of yellow and blue so you will end up with four grids with a huge array of greens. We can expand our range of greens even further by taking any of those mixed greens and adding tiny quantities of either of our reds, giving earthy, brown-greens. Be careful to add only a little though or the colour will go beyond green into a brown or an orange. That in itself takes us in another direction with colour-mixing!

A colour grid using cadmium yellow and Winsor blue (green shade).

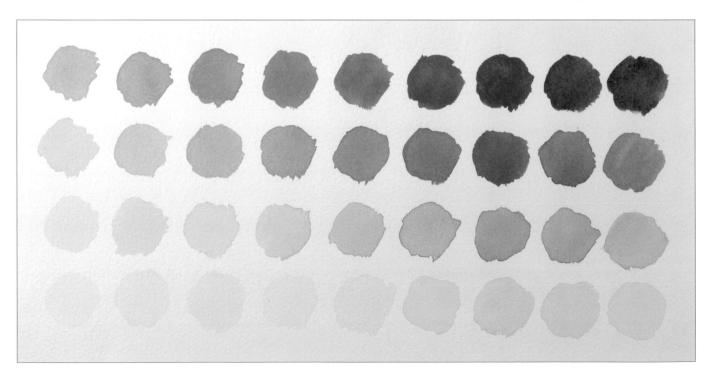

Tone

Tonal contrast is essential when you want something to stand out, such as a light object against a dark background, or vice versa. See how many variable tones you can create on a colour grid using a dark colour at full strength, diluting it as you go until the palest tone is visible.

Tonal exercise: gradated wash

It is not easy to paint a smooth wash of colour (also called a gradated or graded wash) but like most things it does get easier with practise.

This technique is very useful on a sky where the tone is stronger at the top but paler on the horizon.

1 Make sure you are working at a slight angle, then wet the paper with a size 7 series 140 brush to get a gloss on the paper.

2 Make a wash of any dark colour (here I used a useful paint called sepia) by adding the paint to water in the well of your palette to make a fluid but fairly strong mix. Paint a line across the top of the wet area.

3 Clean the brush, then work the wet tip up into the painted line and draw it across the paper below the line in horizontal strokes.

4 Clean the brush and repeat the stroke below the new line. This gradually dilutes the amount of paint in the wet mixture on the paper, creating a gradated effect.

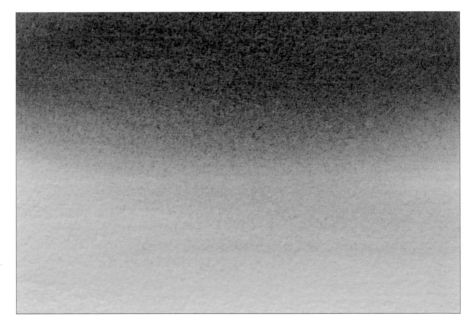

5 Continue working down the paper in the same way, then allow to dry. The darkest tone is at the top, while the lightest tone is at the bottom. Remember that tone is easily altered in watercolour painting by adding water – it is not necessary to add white paint to lighten other watercolour paints.

Tonal exercise: negative painting

A good tonal contrast makes things stand out and creates an impression of depth. With the use of transparent watercolour, white paint is generally not used in quantity. Adding white paint to a colour makes it opaque and therefore duller than adding water to make it paler. If we paint light objects first, we can make them stand out by painting darker tones around them. This is called negative painting.

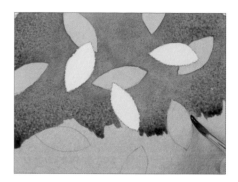

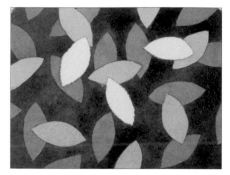

1 Draw a few simple leaf shapes on your paper with an HB pencil, then use a size 7 artist's watercolour sable to make a dilute mix of burnt sienna and Winsor green (blue shade). Paint this mix over all of the paper except for the leaves. Keep the paint moving to avoid a patchy finish.

2 Allow to dry thoroughly. Draw a few more leaves, some underneath the first, some on their own. Make a darker tone of the mix by adding more paint to the mix. This is also called making the mix 'stronger'. Paint around all of the leaf shapes, then allow to dry.

3 Make an even stronger mix by adding permanent rose instead of burnt sienna. This darkens the tone, and also alters the hue a little. Draw some new leaves, and paint around them all as before.

4 Repeat the process a fourth time with a very strong mix of Winsor green (blue shade) and permanent rose. Allow to dry to finish.

Two further examples painted using different hues.

Tonal exercise: monochrome landscape

Where the previous leaf exercise used pale tones to advance and dark tones to create depth, this exercise uses pale tones to evoke distance while the stronger, darker tones come forward.

Achieving the variety of tones in this exercise will teach you how to mix paint with subtlety as well as how to apply the paint smoothly.

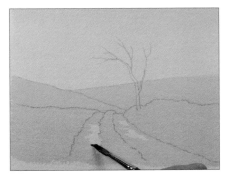

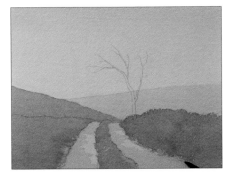

1 Use a pencil to draw a simple landscape as shown, then use a size 7 Artist's Watercolour Sable to add a gradated wash (see page 21) of Winsor blue (green shade) to the top half of the painting.

2 Allow to dry, then add a touch of permanent rose to the blue on your palette and paint a dilute flat wash over the land, leaving two spaces on the path for puddles as shown.

3 Allow to dry, then strengthen the colour on the foreground tracks by adding more paint and a touch of burnt sienna to the mix. While the area is damp, smudge it into the track with a damp brush to soften the edge.

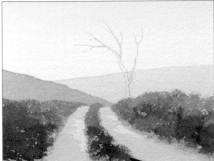

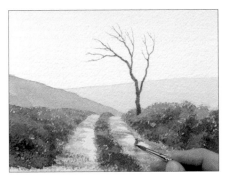

5 Switch to a size 4 Artist's Watercolour Sable brush, and use the same dark-toned mix to add modelling and detail to the road. Paint the basic shape of the tree and its reflection in the puddle.

4 Use a still stronger wash to deepen the tone on the foreground. Load the brush only partially and use the side of the bristles to dab the paint on in a blotchy, variegated manner.

6 Use a size 00 sceptre gold II sable/synthetic brush to add the fine branches to the tree to complete the painting.

Tip
The fine branches can also be added with the split brush technique (see page 16).

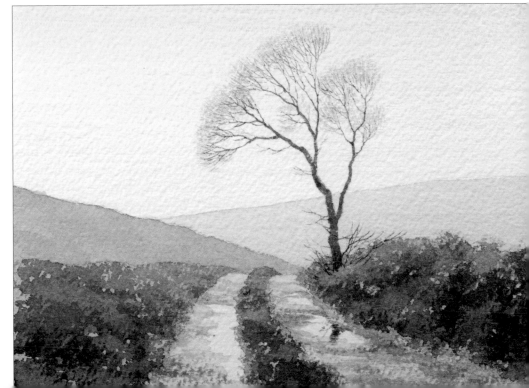

Lakeland Sunset

The painting shown here uses the colours and techniques explained on the previous pages. I have picked out a few details to explain and highlight particular techniques for you so that you can see how the theory works in practice.

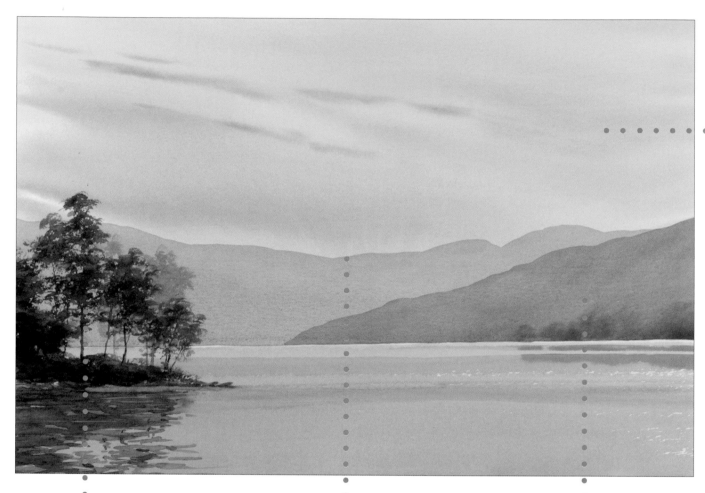

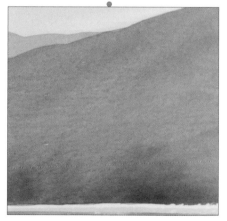

Pale trees were painted into the background by dragging the brush to achieve a broken effect. Once dry, darker tones were painted in the same way for the foreground trees, using the body of the brush, and the tip at the edges.

Once the sky had dried, the hills were painted wet-on-dry with a dilute grey mix of French ultramarine and a small amount of cadmium red.

The orange crest of the hill was painted with the cloud mix (see opposite) combined with a touch of the grey mix.

The darker hills were painted with stronger mixes of the same oranges and greys. Stronger, thicker mixes of burnt sienna and French ultramarine were dropped in damp-into-damp for the trees at the bottom.

The sky area was painted wet-into-wet, with the sky colours mixed beforehand. Once the paper was wet, weak Winsor blue (green shade) was applied only to some of the sky area, leaving spaces for the clouds.

The clouds were painted with two dilute mixes: pale permanent rose with a touch of cadmium yellow, and cadmium yellow with a touch of permanent rose.

The darker clouds were painted damp-into-damp with a slightly stronger mix of French ultramarine and a touch of cadmium red.

I was careful to ensure that the blue and the orangey-yellow in the sky were not too strong where they met. This ensured that the colours did not blend together and make green.

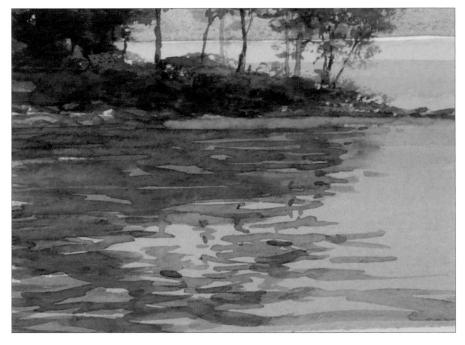

The water and reflection were painted in layers of successively darker tones, letting each dry before applying the next. I used horizontal strokes of the brush for the ripples to emphasise the flatness of the calm water.

Sketchpads

A sketchpad is absolutely essential. No artist should be without one! This is your reference and your source material. I use various different sketchbooks, including a cartridge paper pad for quick sketches and a watercolour paper sketchpad for more careful work.

Try to get used to using a sketchbook on a regular basis as a visual diary. Take it on holiday with you: it can be a private, personal record of the things you have seen and the places you have been.

Write the date on each study, and add a note on how long you took to finish the sketch. How long the sketches take you to do does not matter at all. It is what you do with the time that is important.

Sketchbooks are great: write your thoughts, add colour notes, stick things in them – put anything in them that will help you to learn.

Tip
I like to leave space around the edge of my sketches. The white of the paper acts a bit like a mount or a frame.

Keep sketches simple and do not get bogged down in details. The houses here, for example, are just an impression made with a few light brushstrokes.

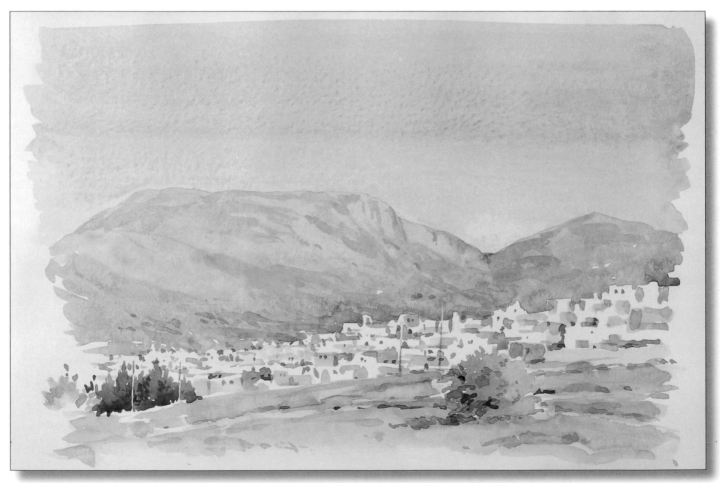

Keep things fresh and do not overwork sketches. Too many layers of paint will make a study muddy and dull.

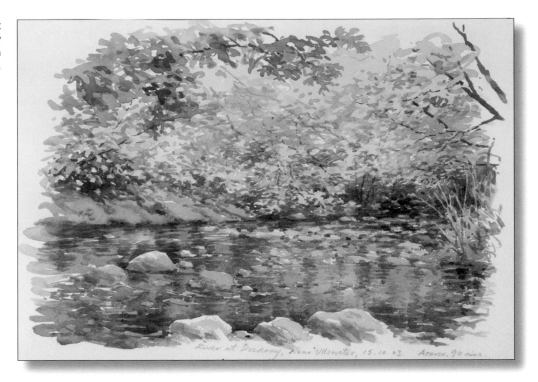

Paint light areas first and gradually work towards the darker shades. Look for contrasts of tone and colour when sketching, as these are important considerations when you come to use your sketch as a point of reference.

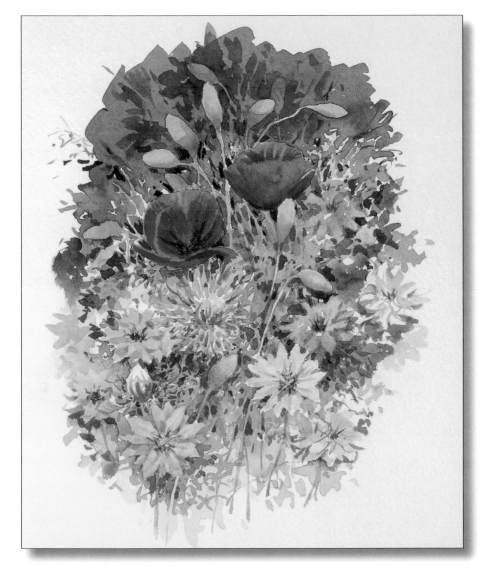

I nearly always use a pencil before adding colour. Just draw the basic shapes so that you know where you will be painting the different parts of the study. In this example, I sketched the top of the thistle beforehand so that it would stand out against the darker background when colour was added to the sketch.

Demonstrations

With paints and brushes at the ready, you can now take your first steps into watercolour painting.

The first painting, *Blustery Day at Hope Cove*, builds on the basic techniques explained earlier in a practical way, showing you how to use the wet-into-dry, wet-into-wet and damp-into-damp techniques to produce a beautiful seascape. All of the techniques combine to produce a picture with light, depth and space.

Floral Bouquet, the second demonstration, shows you how to use many of the same techniques in a different context to paint a flower portrait. Masking is also introduced to keep areas of the paper light.

Some of the colour mixes in the third painting, *Riverbank at Early Morning*, require patience and care as too much of one colour in the mix can take it in the wrong direction. Add colours in small amounts until the right mix is achieved. While it is a little more challenging than the previous paintings, this demonstration reinforces the techniques learnt so far, and is very rewarding.

Once you have worked through the demonstrations, you can apply what you have learnt to making your own pictures. Good luck!

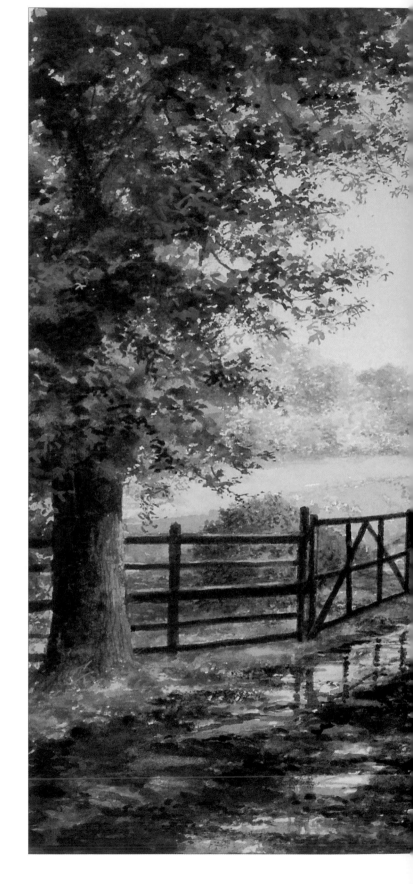

From Dildawn, Dumfries and Galloway
38 x 30cm (15 x 11¾in)
Once you have worked through the demonstrations to practise and consolidate the techniques covered in the previous sections, there is no reason why you should not tackle paintings like the one shown here.

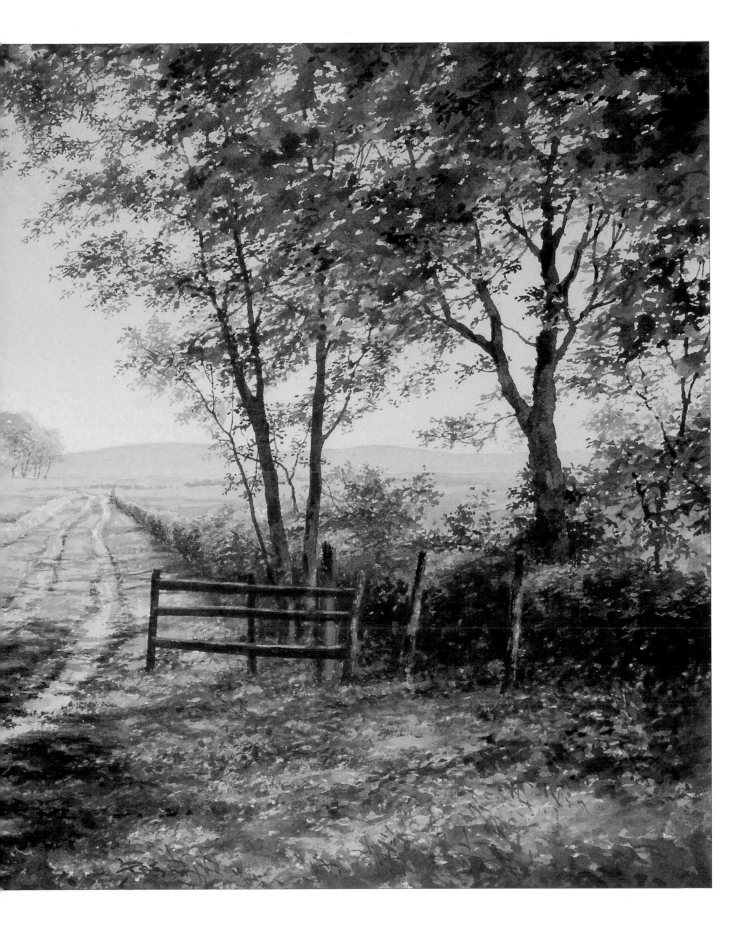

Blustery Day at Hope Cove

Now to put what we have been learning into practice. If you are unsure about a particular stage, try it on a bit of spare watercolour paper first so you will be better prepared and know what to expect.

You will need

Watercolour paints: French ultramarine, Winsor blue (green shade), cadmium red, burnt sienna, cadmium yellow and raw sienna

Paintbrushes: size 1 Artist's Watercolour Sable, size 4 Artist's Watercolour Sable, size 10 Artist's Watercolour Sable, ½in flat series 777 Cotman

A3 300gsm (140lb) paper

Pencil

1 Use the pencil to draw a line slightly under halfway for the horizon, then sketch in the hills on the right and the figures in the centre. Fill in the shoreline as shown below the figures.

Tip
Always begin by mixing the colours ready for each stage of the picture, and test them on a spare scrap of paper. It is better to mix too much of a colour than not enough!

2 Make plenty of the following mixes: a clear sky mix of French ultramarine, a cloud mix of weak raw sienna and a cloud shadow mix of French ultramarine with a small amount of cadmium red and a touch of raw sienna. Using the size 10 brush, start painting the top left of the sky wet-into-dry with the clear sky mix.

3 Quickly soften the edge of the paint with a clean, damp (but not wet) brush.

4 Wet the area to the right with clean water, making sure to leave a thin border of dry paper next to the blue. Drop in the cloud mix wet-into-wet.

5 Working wet-into-wet, add the cloud shadow to the bottom of the cloud area, allowing it to bleed into the cloud mix. If the shadow does not soften at the top, use a soft dry brush to encourage it to disperse a little.

6 Paint the next area of blue with the clear sky mix wet-into-dry, being careful not to touch the damp cloud to the left.

7 Soften the edges as before to suggest the transition from clear sky to cloud.

8 Paint a second large cloud to the right using the same techniques and mixes as before. This completes the top bank of clouds.

9 Add a touch of blue to create the bottom of the first bank of clouds, softening any hard edges with a clean, damp size 7 brush.

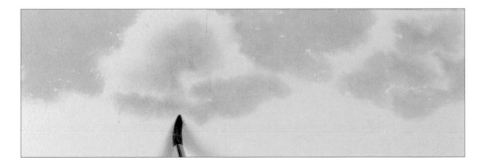

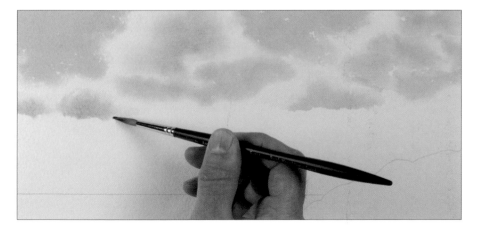

10 Still using the size 7 brush, use the cloud and cloud shadow mixes wet-into-wet to paint a slightly smaller bank of clouds below the first. Soften any hard edges with a damp brush.

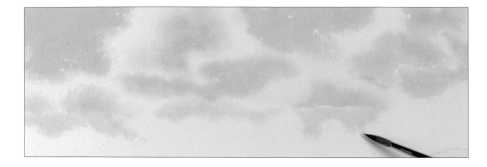

11 Allow the painting to dry completely, then wet the area between the new clouds and add a touch of blue wet-into-wet. Suggest the shape of a third bank of clouds below using the clear sky mix as shown, softening the edges as before.

12 Dampen the central area of the second bank of clouds and add a series of small clouds with the two cloud mixes.

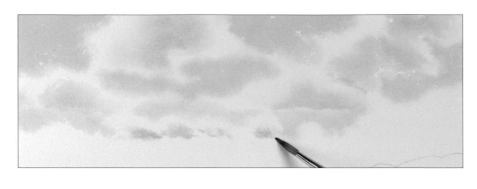

13 Continue the row of small broken clouds to the left- and right-hand edges of the painting, before softening them off.

14 Use a damp brush with a weaker wash of the clear sky mix to add a broken line of clear sky below the second bank of clouds. Soften any hard edges, but do not be too fussy as small patches of clean paper help to add interest and perspective to the sky.

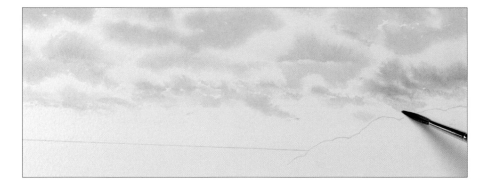

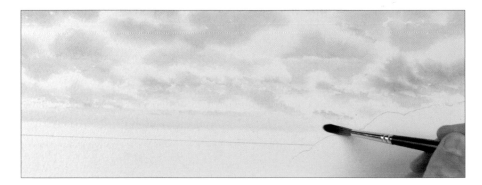

15 Add a further, thinner broken line of clouds below the last line, then wet your brush and use broad horizontal strokes to draw weak sky colour down below the lower bank of clouds.

16 Draw the colour down to the horizon in a gradated wash (see page 21) and allow it to dry. Combine the cloud shadow and clear sky mixes to produce a blue-grey mix (make sure it is not too strong). Still using the size 7 brush, use a very dilute wash of this blue-grey to paint the distant hills over the bottom of the sky.

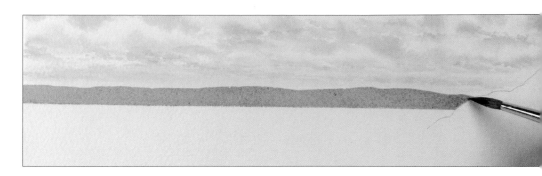

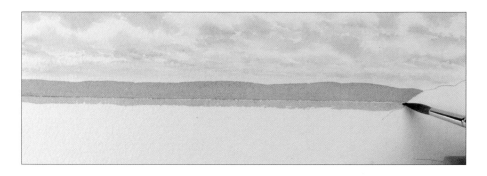

17 Allow to dry thoroughly, then make a sea mix of French ultramarine with small amounts of Winsor blue (green shade) and raw sienna. Working wet-into-dry, paint a narrow band of water beneath the distant hills on the horizon.

18 Paint further bands beneath the first, leaving small white strips of clean paper to represent foam. Make the bands broader as you advance, and use a damp brush so the surface of the paper creates a broken effect.

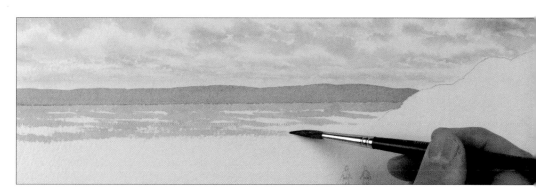

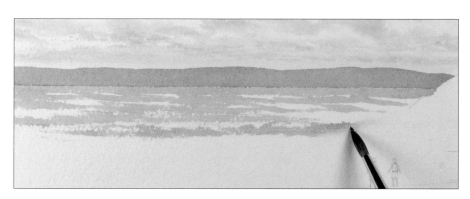

19 Use clean water to wet the splash area on the right, where the sea hits the rocks. Continue painting broad broken strokes of the sea mix to the left, allowing the paint to bleed into the wet area slightly.

20 Paint a stroke of the sea mix underneath the splash area, allowing it to bleed into the water from below.

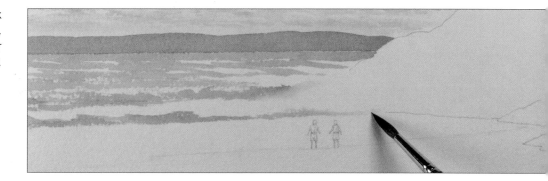

33

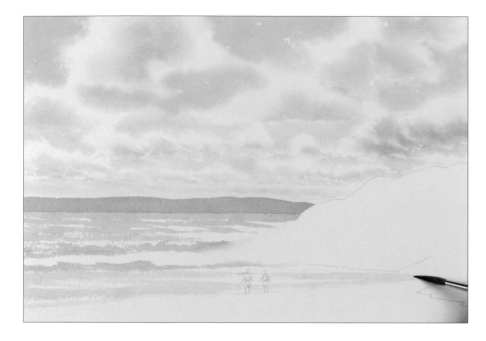

21 Switch to a dilute wash of the clear sky mix (French ultramarine) and continue painting strokes across the painting down to the water's edge to create the shallows. Be careful to avoid painting over the figures. Allow the painting to dry completely.

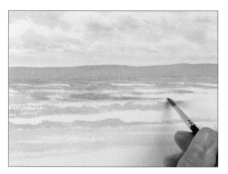

22 Using a slightly stronger sea mix, switch to the size 4 brush and paint over some of the dry sea, leaving strips of the original colour showing through.

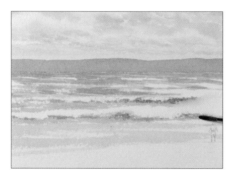

23 Partially load the brush with the sea mix and touch the side of the bristles underneath white foam areas to create the effect of foam.

Tip

It is a good idea to practise this on a piece of spare paper first, to ensure that you have just the right amount of paint on the brush.

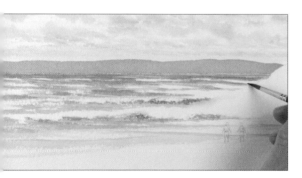

24 Use the blue-grey mix and paint underneath the foam areas in the foreground sea using the tip of the brush, then use a stronger mix of the same colour to darken strips in the background sea.

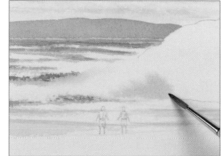

25 Dampen the splash area in the foreground, and add a pale mix of the blue-grey to the bottom right of the main burst.

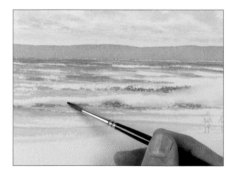

26 Use the same mix on the rest of the white areas, being careful to dampen and paint only the bottom parts of the foam here and there.

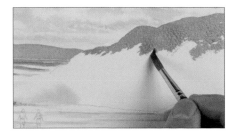

27 Mix a grass colour of cadmium yellow with a slightly smaller amount of French ultramarine; a cliff shadow mix of burnt sienna and French ultramarine; and prepare some pure burnt sienna for the cliffs. Working from the top down, use the size 7 brush to paint the grass mix down to the level of the background hills.

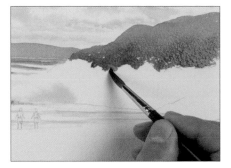

28 While the grass mix is wet, introduce some burnt sienna so the paints blend together on the dry paper. Continue painting down to level with the sea.

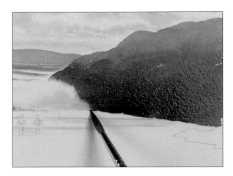

29 Work the cliff shadow mix in and draw it down to the beach, before taking it over to the splash area. Quickly clean and dampen your brush and use it to soften the hard edge of the spray to create a misty effect.

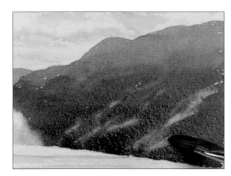

30 Use the corner of the ½in flat brush to lift out highlights on the base of the cliff and allow to dry.

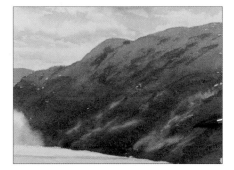

31 Detail the cliff with a size 4 brush, using a mix of cliff shadow and green for the top part, and cliff shadow on the bottom part.

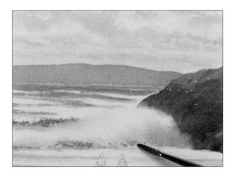

32 Re-wet the splash area and add a touch of blue-grey mix (French ultramarine with touches of cadmium red and raw sienna) to the lower right to reinforce the impact of the wave.

33 Make a sand mix of raw sienna with a tiny amount of burnt sienna, and even less French ultramarine. Use the size 4 brush to paint narrow strips of beach underneath the cliffs and sea, leaving a tiny gap of clean white paper between elements. Quickly paint strokes of the sky mix between the strips of beach as shown, allowing the wet paint to bleed together slightly.

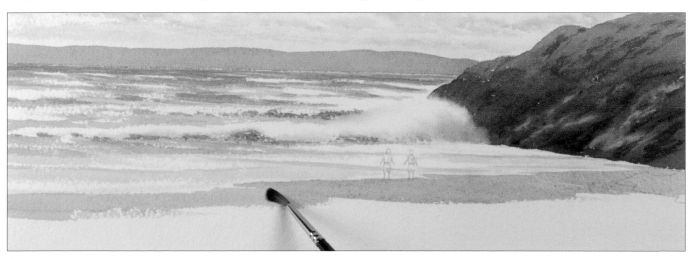

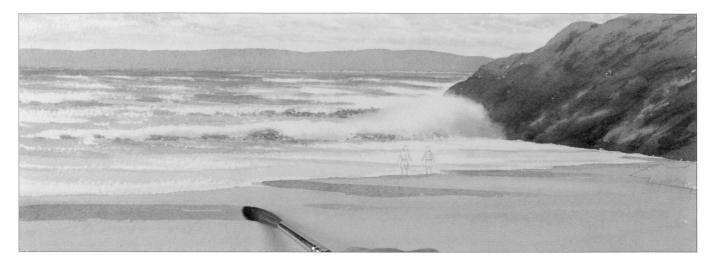

34 Switch to the size 7 brush and use the sand mix to block in the beach down to the bottom of the paper. Allow to dry, then add a touch of the cliff shadow mix to the sand mix. Use this to paint the areas of wet sand where sea and sand meet with broad horizontal brushstrokes.

35 Use a damp brush to soften the brushstrokes into the dry sand.

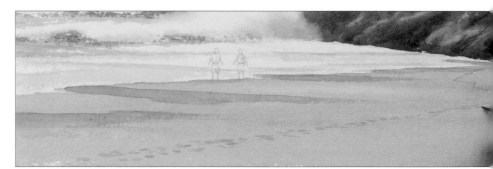

36 Use the size 1 brush with the darkened sand mix to paint a row of subtle footprints across the sand. Use small horizontal strokes, starting larger on the left and gradually getting smaller as they recede to the right.

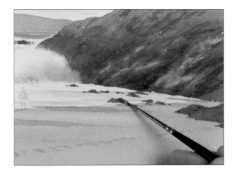

37 Still using the size 1 brush, add some scattered rocks on the lower right with the cliff shadow mix. Make sure the bottoms are flat.

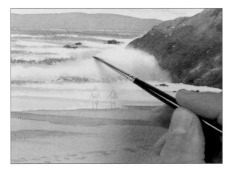

38 Wet the area above the splash and add a touch of blue-grey to make the white foam stand out.

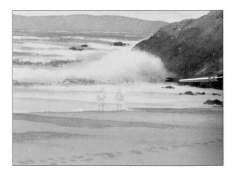

39 Without cleaning the brush, drag it across the front of the wave to add texture.

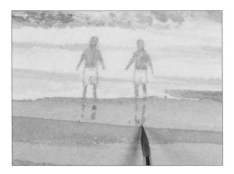
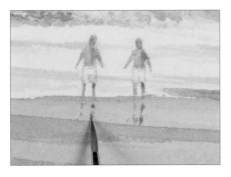
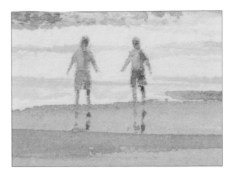

40 Using a weak mix of cadmium red and burnt sienna, paint the figures, leaving a space for their shorts. Use the same colours to paint broken reflections underneath them.

41 Once dry, overlay the heads, right side of the backs, right arms and right legs of the figures and reflections with the same mix to provide natural shading.

42 Paint the left-hand figure's shorts with Winsor blue (green shade) and paint the other figure's shorts with cadmium red.

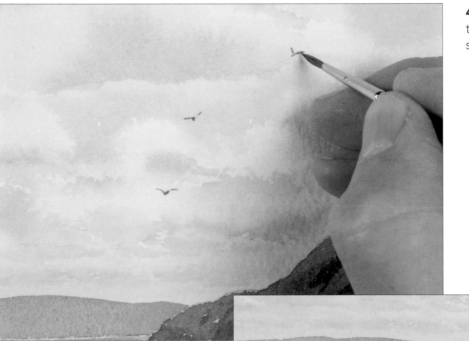

43 Use the cliff shadow mix to add some simple v-shaped seagulls above the cliff.

44 To finish the painting, draw a horizontal streak across the figures' reflections with a very dilute mix of the cliff shadow colour.

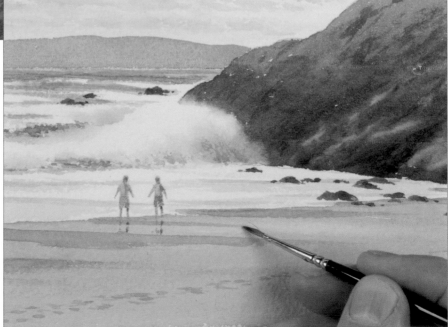

The finished painting

34.25 x 24cm (13½ x 9½in)

I have painted this picture many times. Use every painting opportunity as a learning experience. If your first attempt was difficult, try it again. If you do it again, think how you could do it differently. A mistake is a stepping-stone to success!

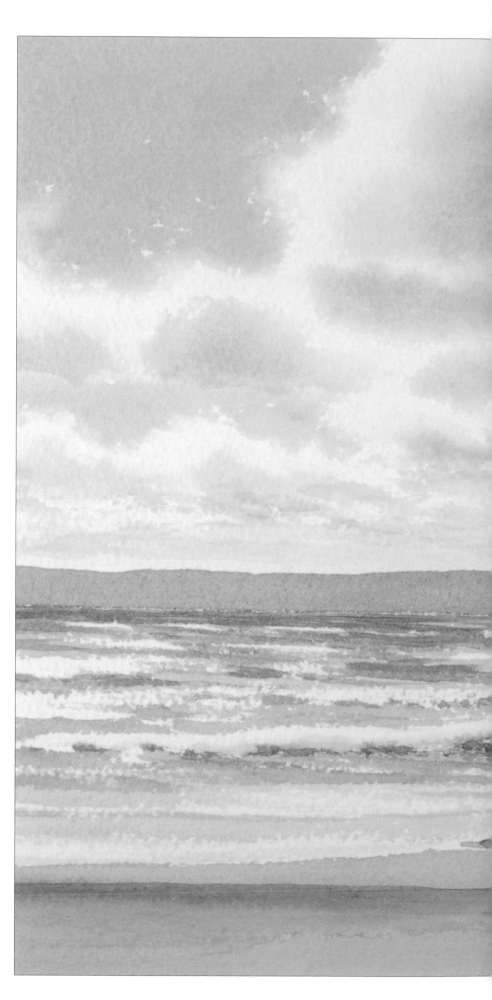

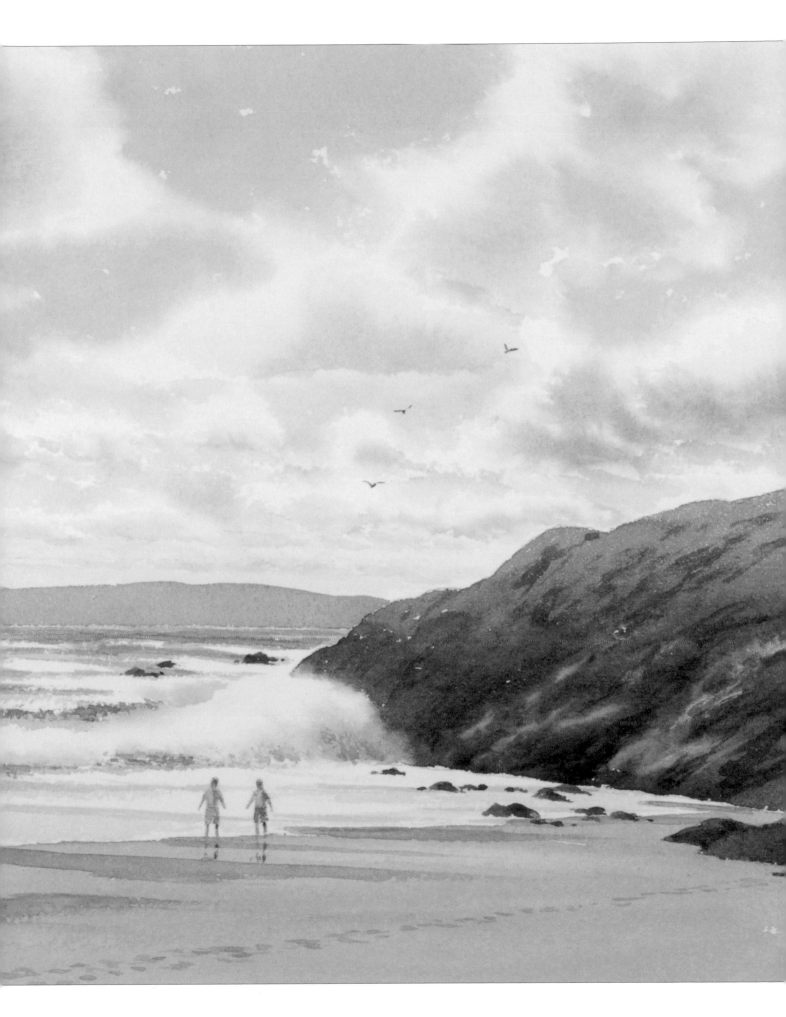

Floral Bouquet

Speed is essential when painting wet-into-wet or damp-into-damp because each of the background colours needs to be applied while the paper is wet or damp. If you can not see the shine on the paper, do not put any more paint on. Instead, let the paper dry completely, then re-wet the paper as before and continue.

You will need

Watercolour paints: burnt sienna, raw sienna, French ultramarine, Winsor blue (green shade), cadmium yellow, Winsor lemon, permanent rose, cadmium red

Paintbrushes: size 1 Artist's Watercolour Sable, size 4 Artist's Watercolour Sable, size 10 Artist's Watercolour Sable, ½in flat series 777 Cotman, size 2 Artist's Watercolour Sable short handle rigger, series 140 7/8 mop brush

A3 300gsm (140lb) paper

Pencil

Masking fluid and old brush

1 Use the pencil to sketch the main flowers' shapes as shown.

2 Use an old brush to apply masking fluid over all of the flowers and on the stems of the gypsophila. To avoid the masking fluid drying and damaging the brush, rinse it in water between applications, removing excess water from the brush before dipping it back into the masking fluid. Prepare a well of permanent rose and the following mixes: violet, from permanent rose and French ultramarine; warm yellow, from cadmium yellow and Winsor lemon; orangey-brown, from raw sienna and burnt sienna; mid-green, from cadmium yellow with a little French ultramarine; and green-grey, from French ultramarine and burnt sienna.

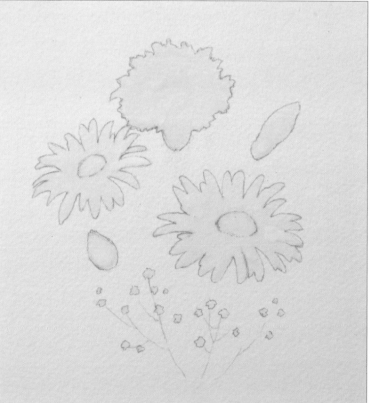

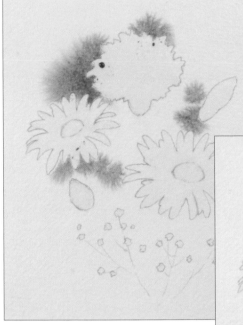

3 Wet the paper all over with the mop brush, then add some drops of permanent rose wet-into-wet as shown.

Note

When wetting the paper, apply a generous amount of water. Ideally, the paper should not dry until you finish step 9.

4 Add an area of warm yellow in the centre, allowing it to bleed and spread into the pink a little.

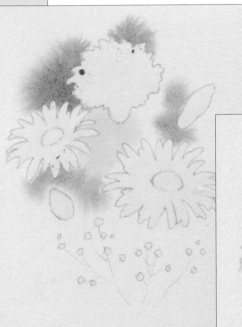

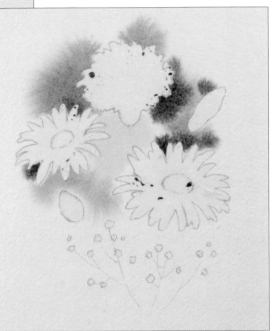

5 Add some of the violet mix in and amongst the pinks, still wet-into-wet.

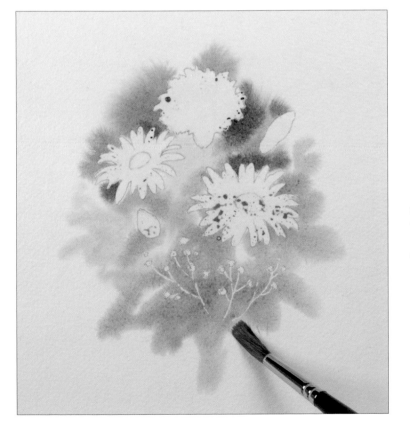

6 Use the mid-green wet-into-wet to suggest the foliage and stems, moving the brushstrokes outwards from the centre.

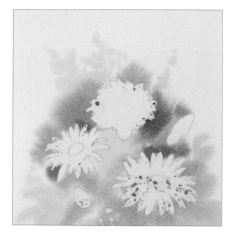

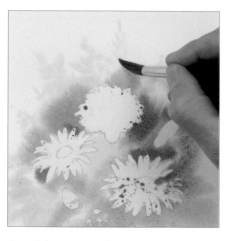

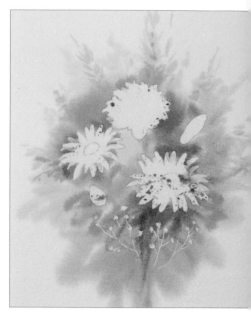

7 To achieve the more controlled foliage at the top, use a damp (but not wet) brush (see page 15 for the damp-into-damp technique).

8 Add an area of orangey-brown on the right and expand the controlled foliage with the same colour on a slightly dryer brush.

9 Use the green-grey mix (French ultramarine and burnt sienna) to suggest darker stems and foliage. This gives depth and adds shading to the larger flowers.

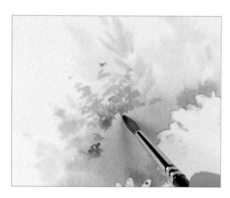

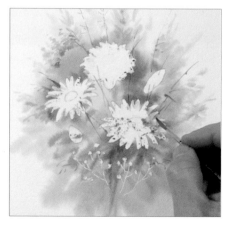

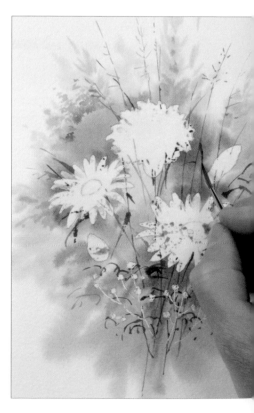

10 Allow the painting to dry completely, then dilute the violet mix and use a size 4 brush to suggest sprigs of small flowers in the top left. Use a stronger tone at their bases to suggest the edges of a pink flower below them.

11 Use varying combinations of the mid-green (cadmium yellow with a little French ultramarine) and orangey-brown mixes with the rigger to create grasses in and around the flowers.

12 Add darker stems with combinations of the mid-green and green-grey mixes.

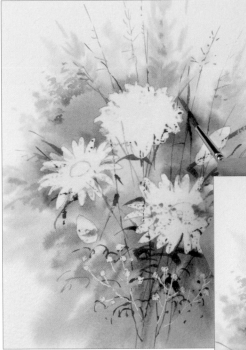

13 Make a dark green mix from Winsor blue (green shade) and burnt sienna. Use this mix with a size 4 brush to add larger leaves and stems as shown.

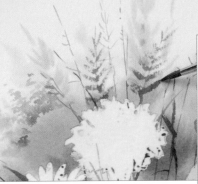

14 Use a damp brush to add fern shapes at the top of the foliage using the same mix.

15 Using the size 4 with a mix of permanent rose with a touch of French ultramarine, scribble some modelling into the pink area on the top left to identify it as a carnation. Use a stronger mix lower down to add shading.

16 Use a damp ½in flat brush to lift out (see page 15) a stem beneath the central carnation. Remove the paint from the brush and repeat if necessary.

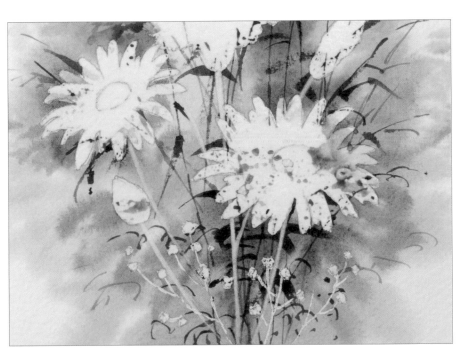

17 Use the same brush to lift out stems for the other main flowers.

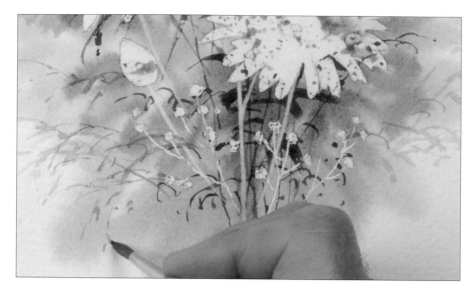

18 Use a very dilute mix of raw sienna and French ultramarine to paint some faint foliage to the lower left and right of the painting, using the size 4 round brush.

19 Use a pale mix of cadmium yellow with a touch of French ultramarine and paint the lifted-out stems of the flowers.

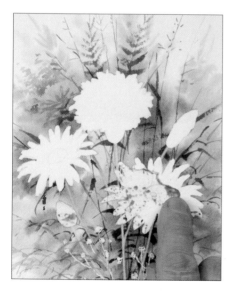

20 Allow the painting to dry thoroughly, then use a clean eraser (or your finger) to gently rub away all of the masking fluid. Work slowly and carefully to avoid smearing or creasing your work. Be very careful not to tear the paper.

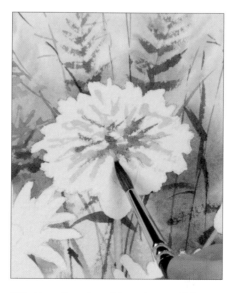

21 Use the size 4 brush to add dilute permanent rose to the central carnation using short sharp brushstrokes outwards from the centre. Use stronger colour in the centre of the flower.

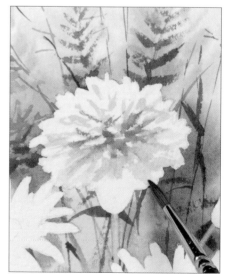

22 Add a tiny touch of cadmium red to very pale French ultramarine to make a pale blue-grey. Use this mix to add shading to the lower petals of the carnation.

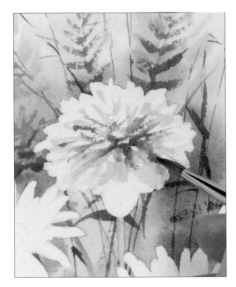

23 Strengthen the centre with further dark pink strokes.

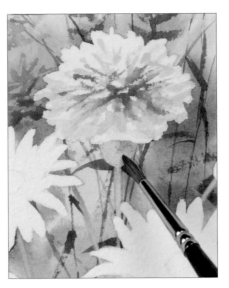

24 Use a pale tint of the mid-green (cadmium yellow with a little French ultramarine) to fill in the stem and area beneath the petals. Add a touch of dark green (Winsor blue [green shade] and burnt sienna) wet-into-wet for shading on the right.

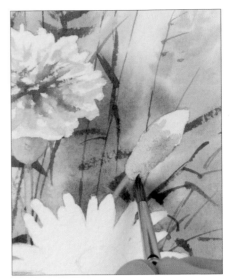

25 Paint the bud to the right of the carnation with the same green mixes, leaving a small area of clean paper at the top as shown.

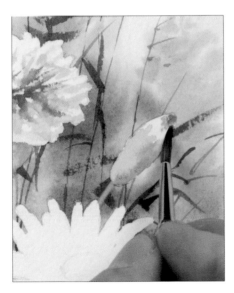

26 Add a touch of permanent rose to the tip of the bud, and add the dark pink mix in wet-into-wet.

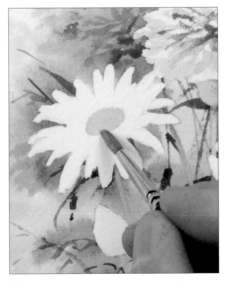

27 Prepare some pure cadmium yellow, and a mid-brown mix of burnt sienna with a touch of French ultramarine. Paint the centre of the left-hand daisy with cadmium yellow.

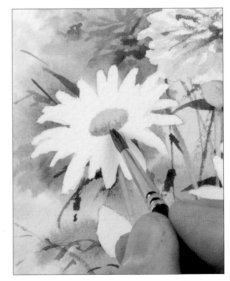

28 Working wet-into-wet, add shading to the lower part of the daisy centre using the mid-brown mix.

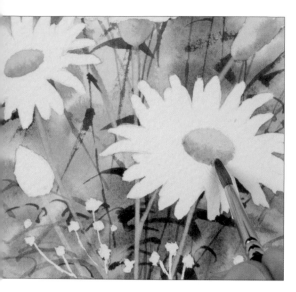

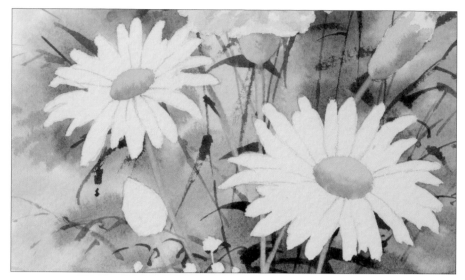

29 Paint the centre of the other daisy in the same way, then allow to dry thoroughly.

30 Use a pencil to suggest the shape of a few petals on each daisy.

Note

This is negative painting: the shaded petals appear to recede, giving the impression that the unshaded petals are closer to you.

31 Switch to the size 1 brush and use it to shade the petals of the left-hand daisy using French ultramarine with a touch of cadmium red.

32 Paint the petals of the other daisy in the same way.

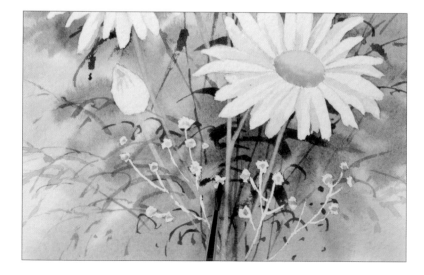

33 Use the same mix to detail the top of the bud on the lower left, and the centres of the gypsophila flowers.

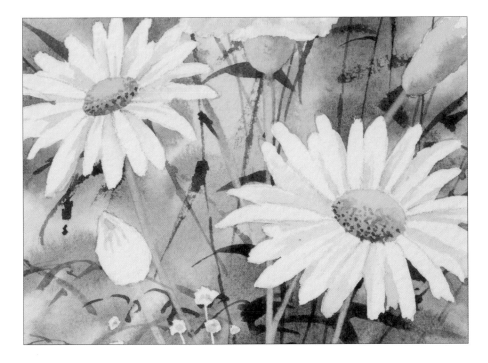

34 Use a stronger mix of the mid-brown (burnt sienna with a touch of French ultramarine) to stipple the lower parts of the centres with the tip of the size 1 brush. Use a slightly more dilute mix as you near the upper centres.

35 Strengthen the daisy shading mix (touch of cadmium red and French ultramarine) and add touches of the new colour in the recesses near the centre of the daisies as shown.

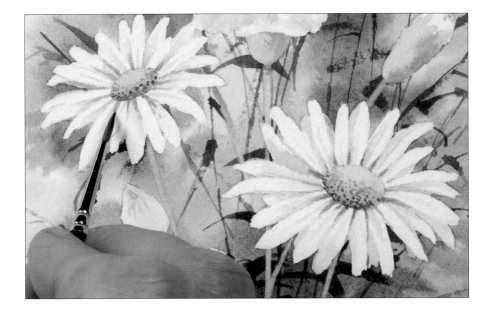

36 Use strong mixes of the respective background colours to tidy the edges of any petals that are a little ragged.

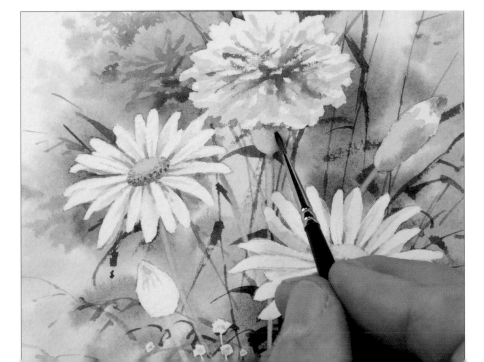

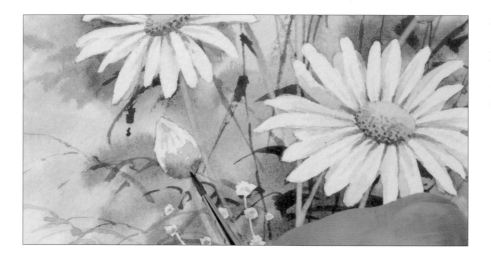

37 Paint the bud on the lower left with mid-green (cadmium yellow with a little French ultramarine) in the centre and dark green (Winsor blue [green shade] and burnt sienna) wet-into-wet nearer the base.

38 Use a pale mix of mid-green to paint the gypsophila stems.

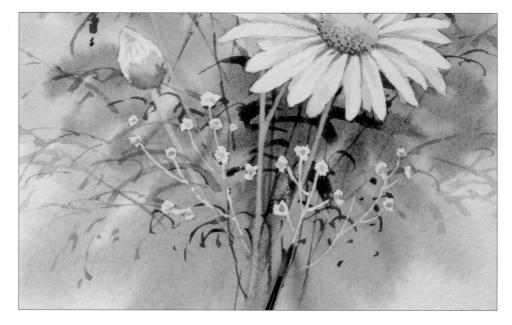

39 Add a touch of mid-green on either side of the main stems to add impact to the finished piece.

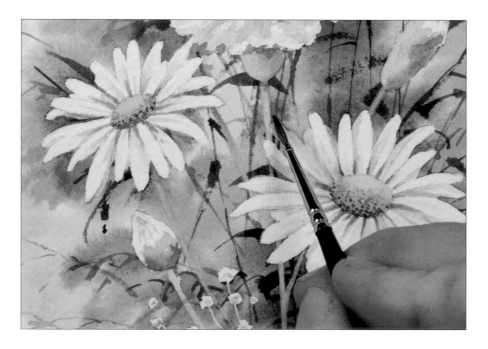

Opposite
The finished painting
24 x 34cm (9½ x 13⅜in)
The soft, out-of-focus background contrasts nicely with the foreground flowers. This produces a bright, effective arrangement.

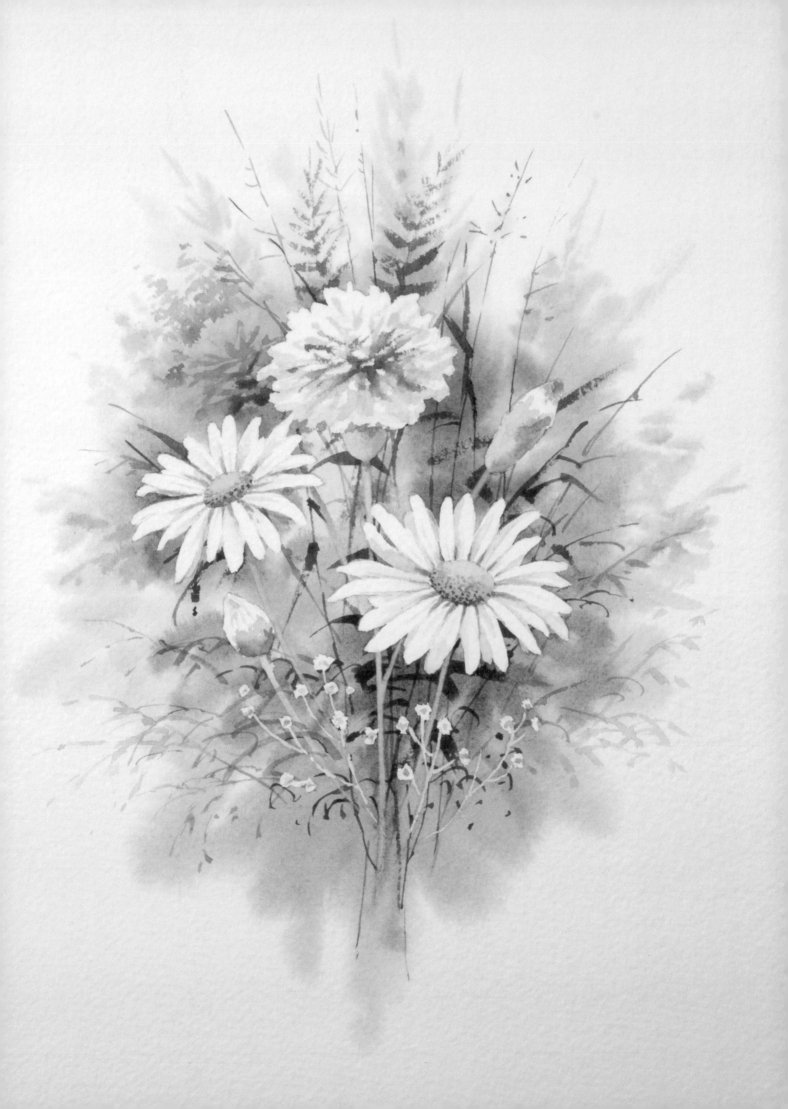

Riverbank at Early Morning

This demonstration uses masking fluid in a different context but for the same effect: contrasting light against dark. Get all of the mixes ready at the start of each stage so you do not have to stop and mix more at a crucial stage.

You will need

Watercolour paints: raw sienna, cadmium yellow, permanent rose, burnt sienna, Winsor blue (green shade), Winsor lemon, cadmium red, French ultramarine

Paintbrushes: size 1 Artist's Watercolour Sable, size 4 Artist's Watercolour Sable, size 7 Artist's Watercolour Sable, size 10 Artist's Watercolour Sable, size 2 Artist's Watercolour Sable short handle rigger

A3 300gsm (140lb) paper

Pencil

Masking fluid and old brush

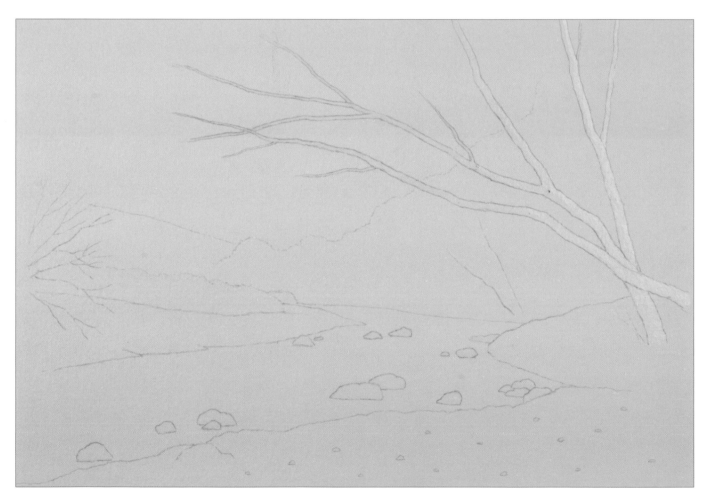

1 Use the pencil to sketch out the main shapes, then apply masking fluid to the tree, rocks, branches and top of the gorse on the left.

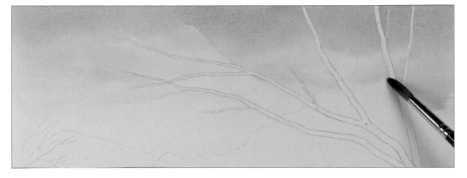

2 Prepare a sky mix of Winsor blue (green shade) with a small amount of permanent rose and a touch of raw sienna; and a sunny mix of raw sienna with a little burnt sienna. Use the size 10 brush to wet the upper half of the picture and drop the sunny mix in halfway up the sky.

3 Working wet-into-wet, add the sky mix above the sunny mix, allowing the colours to merge and blend. Allow to dry thoroughly. Add a touch more Winsor blue (green shade) to the sky mix for a misty background hill mix, then prepare some raw sienna; burnt sienna; a dark brown mix of burnt sienna with a little French ultramarine; and an inky-grey mix of Winsor blue (green shade), permanent rose and a touch of burnt sienna.

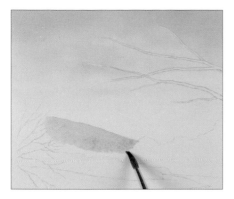

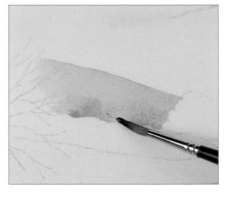

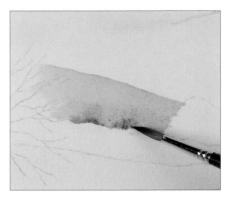

4 Dampen the area on the left, then use a size 7 brush with the misty mix to paint in the top half of the distant hills.

5 Working wet-into-wet, add areas of raw sienna and burnt sienna to the lower half of the hills, allowing the colours to bleed and merge with one another.

6 Add a touch of the inky-grey mix wet-into-wet where the hills disappear behind the gorse.

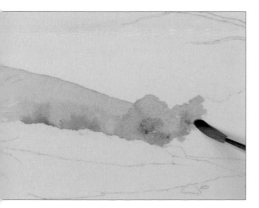

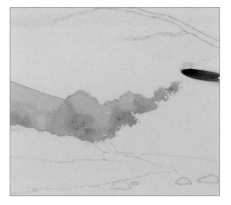

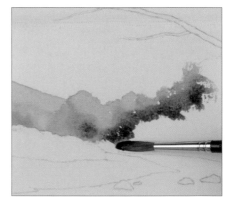

7 Working wet-on-dry, start to fill in the trees in the centre, alternating between raw sienna and burnt sienna.

8 Use a slightly dryer mix at the top of the treeline for a broken, textured feel.

9 Introduce the dark brown mix wet-into-wet as you continue to the right.

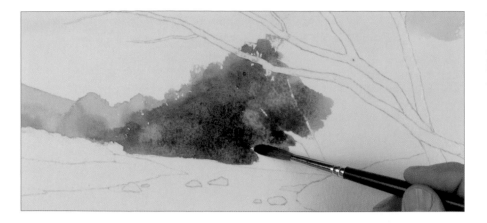

10 Add the inky mix towards the bottom of the trees and then continue to the right, swapping between the four mixes to produce a variegated effect.

11 Use vertical strokes to suggest taller trees in the top right of the background foliage, using a mix of colours as before.

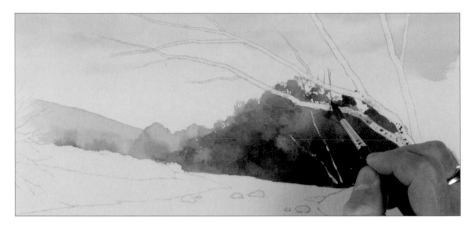

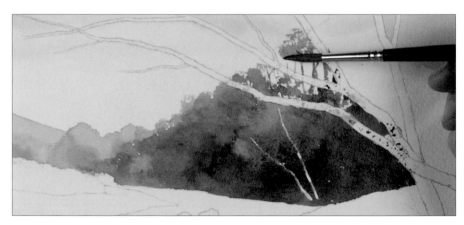

12 Suggest foliage by dragging the side of a drier brush over the vertical strokes.

13 Continue building up the upper and lower areas of the foreground foliage in the same way until you reach the edge of the paper. Leave white patches showing through the top of the foliage as shown.

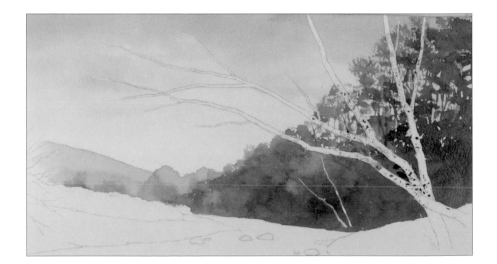

14 Switch to the size 4 brush, pick up a little of the dilute inky colour and split the brush (see page 16). Use this to add twigs in the mid-distance as shown.

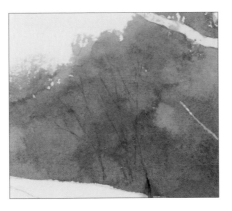

15 Use the size 1 brush to paint faint branches in the middle distance, alternating between the inky and dark brown mixes.

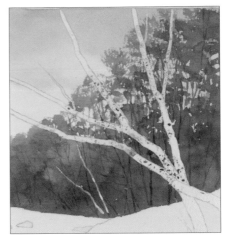

16 Continue adding branches in the woods, using stronger mixes and broader strokes on the closer trees on the right.

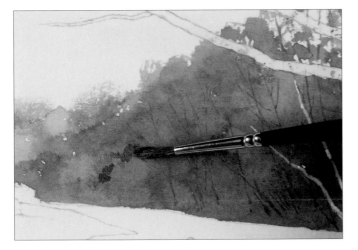

17 Add texture by dragging the size 4 brush here and there over the trees, using the same mixes as used in the branches.

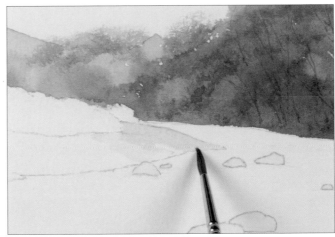

18 Make a yellow-green mix of cadmium yellow and French ultramarine, and prepare wells of raw sienna and cadmium yellow. Use the size 4 brush to paint small sections of the riverbank using dilute raw sienna.

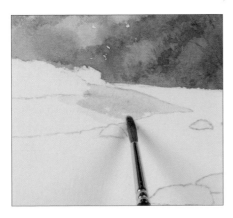

19 Add the yellow-green mix wet-into-wet, allowing the colours to blend.

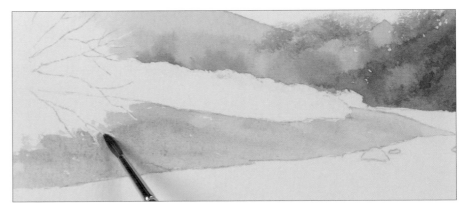

20 Fill in the rest of the gorse bank with a variegated wash of these two colours, keeping the top part more green and using more raw sienna near the water's edge.

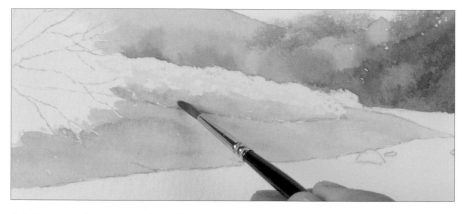

21 Starting from the edge of the bush on the left, paint the gorse bank with a variegated wash of cadmium yellow and yellow-green, using more yellow at the top.

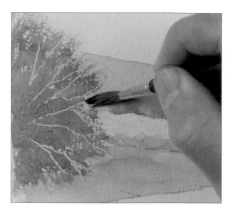

22 Use a fairly dilute mix of the dark brown (burnt sienna and French ultramarine) with a fairly dry size 7 brush to paint the bush on the left-hand side. Drag the paint from the centre outwards to create the impression of twigs.

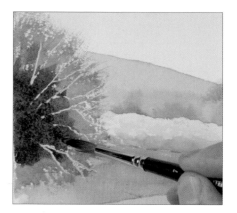

23 Use a stronger mix of the same colour wet-into-wet in the centre to strengthen the colour. Soften the edges of the inside with a clean damp brush.

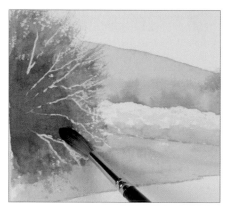

24 Allow to dry, then give the bush a slightly sunny effect by glazing the outside edge with dilute raw sienna as shown.

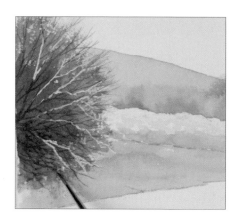

25 When dry, use the dark brown mix to paint fine branches and twigs with the size 1 brush.

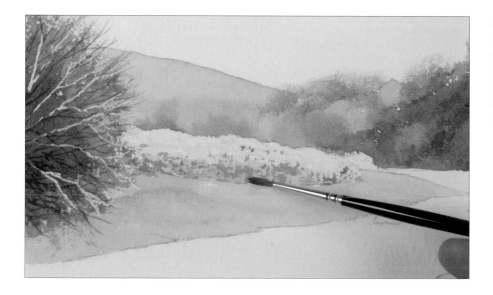

26 Using a damp mix of the yellow-green mix, touch the side of the bristles of the size 1 brush all over the gorse to achieve an uneven effect as shown. If the brush is too wet for this effect, remove the excess on a tissue.

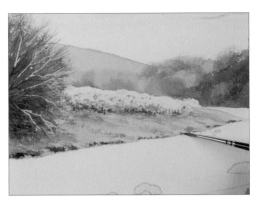

27 Add a touch of burnt sienna to the mix, dilute slightly, and repeat this action over the grass. If any hard edges appear, soften them with a damp brush.

28 Use the dark brown and yellow-green mixes to shade the area under the bush and add modelling to the grass area and at the bottom of the gorse. Use a fairly strong dark brown mix along the water's edge here and there.

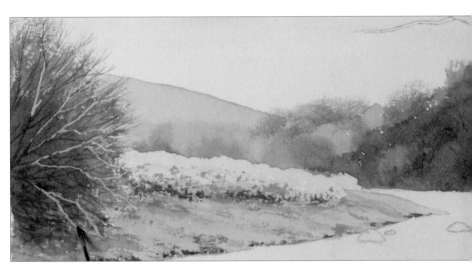

29 Allow to dry, then remove the masking fluid from the top of the gorse and the bush.

30 Use cadmium yellow to fill in the top of the gorse, and use a very dilute wash of the dark brown to go over the bare branches of the bush.

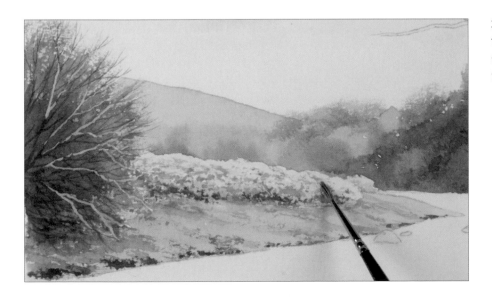

31 Once dry, use the size 1 brush to break up the yellow on the gorse with touches of the yellow-green mix.

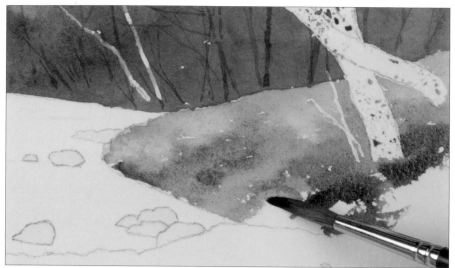

32 Make fresh mixes of yellow green (French ultramarine and cadmium yellow); dark brown (burnt sienna and French ultramarine) and a dark grey of French ultramarine with a little burnt sienna. Use the size 7 brush to paint a variegated wash of these mixes over the right-hand bank, using more yellow-green at the top and the darker mixes at the bottom.

33 As you reach the pebbled area, fade the colour out a little using clean water.

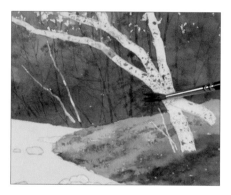

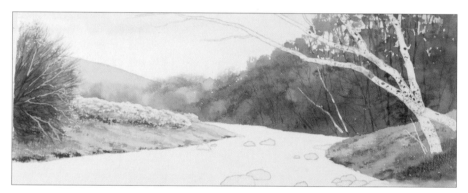

34 Allow the bank to dry, then texture it and the lower woods with the grey and brown mixes using a split size 4 brush.

35 Allow the painting to dry, then glaze the right-hand bank and the whole of the grassy area on the left-hand bank with a very dilute wash of Winsor lemon. Allow to dry.

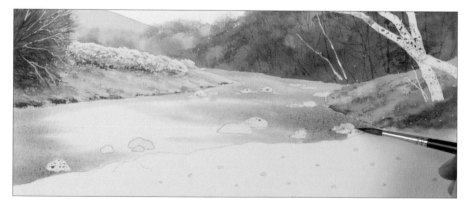

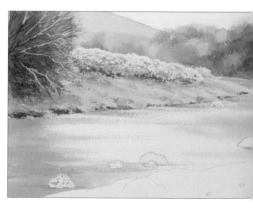

36 Prepare a mix of Winsor blue (green shade) with a small amount of permanent rose and a touch of raw sienna to produce a bluish-grey river mix. Use a size 10 brush to wet the river area, then use a size 7 brush to drop in the river mix on the left and right, before drawing it across the river with horizontal brushstrokes, being careful to leave the centre fairly clear.

37 Allow the paint to dry, then use narrow horizontal strokes of a damp size 7 brush to apply a more dilute blue-grey mix across the river.

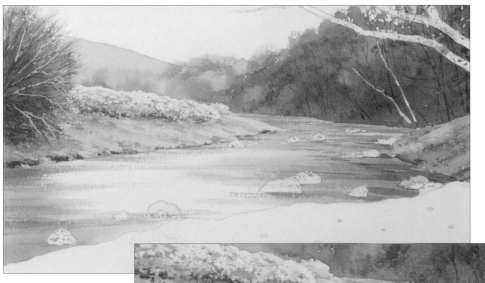

38 Repeat this at the sides of the river with the original, stronger mix to deepen the tone on the left and right.

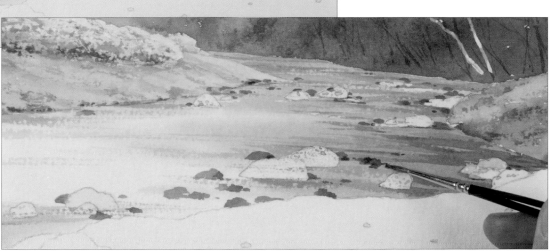

39 Use the size 1 brush with a mix of burnt sienna, French ultramarine and cadmium yellow to add small dark rocks on the water's surface.

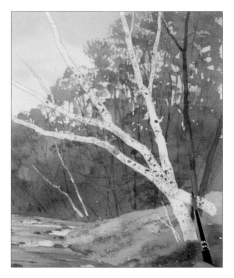

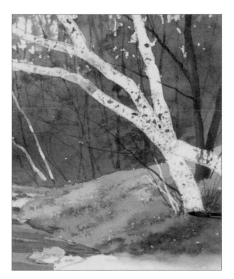

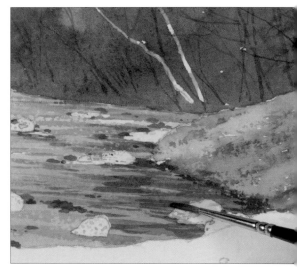

40 Use the same mix with the size 4 brush to paint a shadowy tree behind the main masked-off trees on the right. Vary the tone by adding cadmium yellow wet-into-wet.

41 Add finer branches to the shadowy tree with the size 1 brush and then use the same mix to add some grasses at the base of the masked-off trees.

42 Add some broken texture to the riverbank and right-hand side of the river with the same colour and brush.

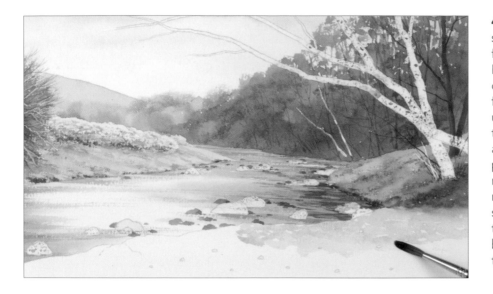

43 Prepare some raw sienna, some burnt sienna and the following mixes: grey, from French ultramarine with a little cadmium red; and yellow-green, from cadmium yellow and French ultramarine. Use the size 7 brush to paint a broken variegated wash across the pebbles, starting with patches of yellow-green below the right-hand grass and along the riverbank, and then adding raw sienna wet-into-wet to mingle with these patches. Allow some little bits of clean white paper to show through, as these add to the effect.

44 Continue the broken variegated wash down across the whole pebbled area, adding the other colours in wet-into-wet as you near the bottom of the paper.

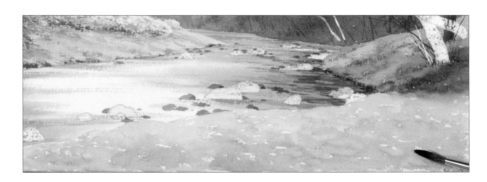

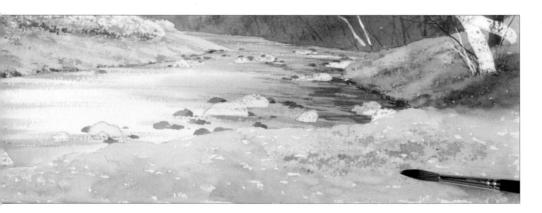

45 Allow the painting to dry, then add a touch of raw sienna to the grey mix and add texture to the pebbled area with the side of the size 7 brush.

46 Continue across the whole area, being careful not to get a repetitive pattern with the side of the brush. Towards the water's edge, use the tip of the brush to scribble some pebble outlines.

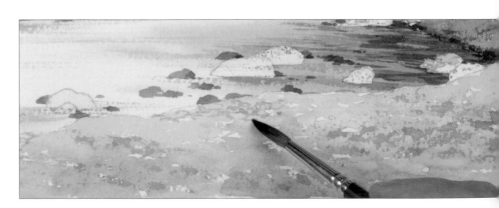

47 Continue building up the texture, scribbling over the area with darker tones.

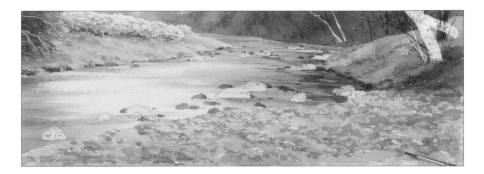

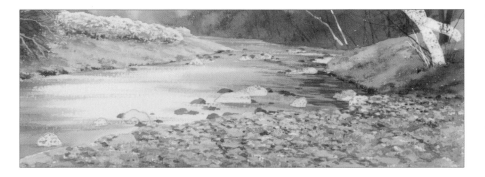

48 Add touches of dark brown and dark grey over parts of the area to suggest recesses between pebbles. This will create depth and texture, and help to build contrast between the tones. Remember that you are painting the gaps between the stones rather than the stones themselves.

49 Once dry, remove all of the remaining masking fluid from the rocks and trees.

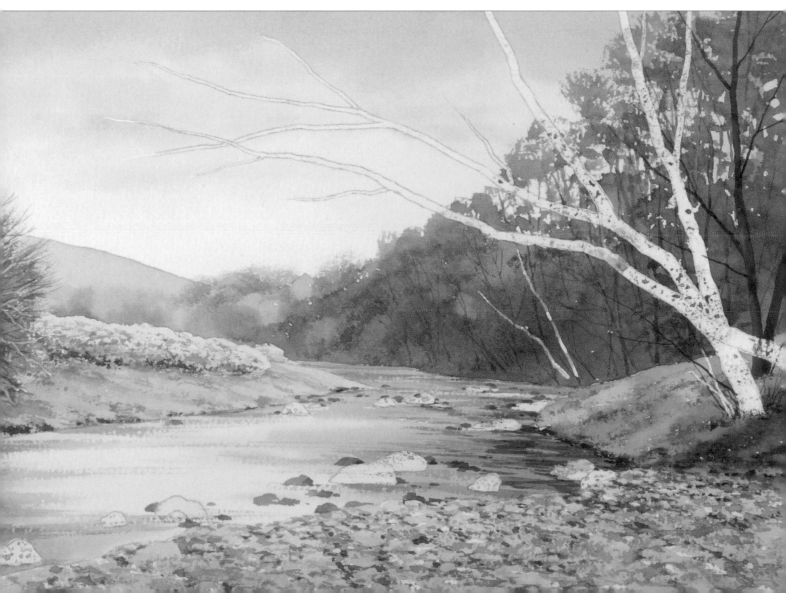

50 Make a pale-to-midstrength mix of cadmium yellow and French ultramarine and use this to paint all over the trees revealed by removing the masking fluid. Drop in a mix of French ultramarine and burnt sienna wet-into-wet to add shading and texture.

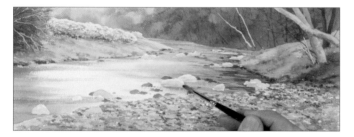

51 Wet the unmasked rocks in the river and paint them with the same mixes used on the trees.

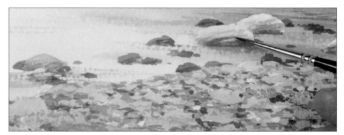

52 Once the rocks have dried, add texture to all the rocks with diagonal brushstrokes of the darker mix applied with the tip of the size 1 brush, paying particular attention to darkening the undersides.

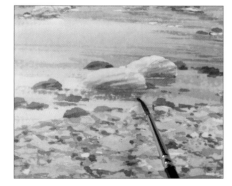

53 Use a dark grey mix of French ultramarine and burnt sienna to add reflections to the rocks by painting broken parallel lines beneath them.

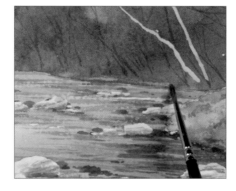

54 Use a damp ½in flat brush to gently lift out the riverbank in the middle distance. Once dry, use the size 1 brush to add raw sienna to the lifted-out area.

55 Add texture to the large trees by dragging the side of the size 1 brush's bristles over them, using the dark grey mix.

56 Use the rigger with the dark grey mix to extend the existing branches on the foreground trees.

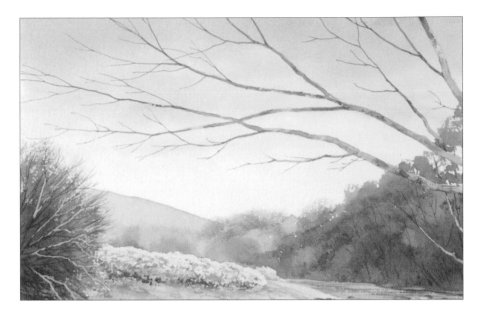

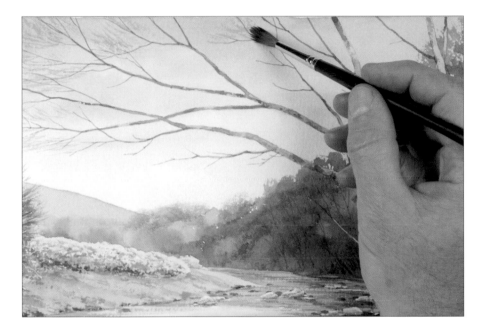

57 Add fine twigs to the branches using the split-brush technique (see page 16) with the grey mix and size 7 brush.

58 Add any finishing touches, such as some additional shading on the pebbles at the lower right to complete the painting.

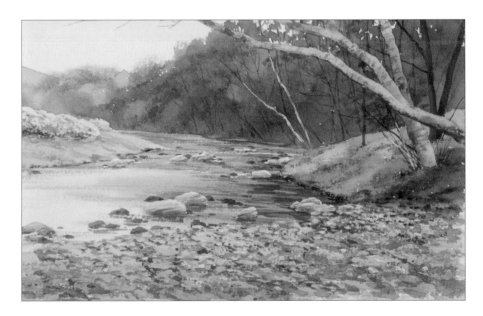

The finished painting
34 x 24cm (13⅜ x 9½in)
The many different techniques applied along with subtle colour mixes and a good range of tones make an interesting and appealing picture.

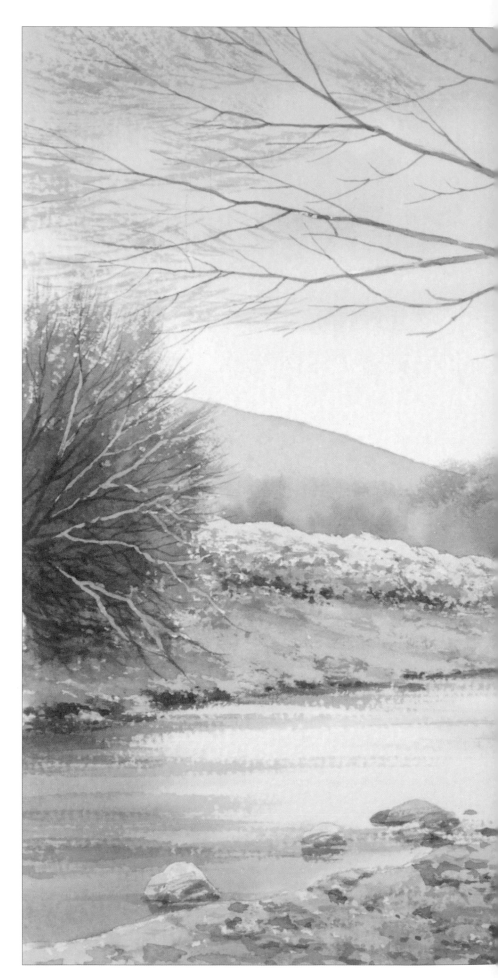

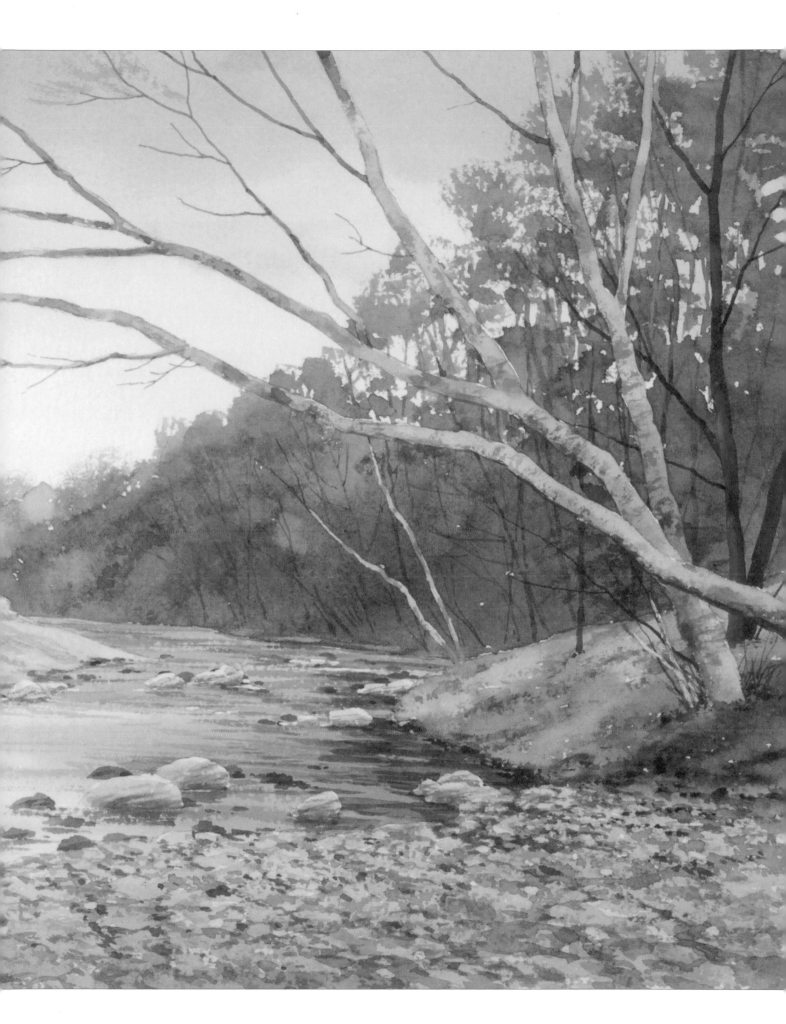

Index

Church Doorway
30 x 38cm (11¾ x 15in)